New Vintage Lace

KNITS INSPIRED
BY THE PAST

ANDREA JURGRAU

INTERWEAVE.
interweave.com

EDITOR: *Ann Budd*

TECHNICAL EDITOR: *Kristen TenDyke*

PHOTOGRAPHER: *Joe Hancock*

PHOTO STYLIST: *Allie Liebgott*

HAIR AND MAKEUP: *Kathy MacKay*

ASSOCIATE ART DIRECTOR: *Julia Boyles*

DESIGN AND LAYOUT: *Lora Lamm*

PRODUCTION DESIGNER: *Katherine Jackson*

Interweave
A division of F+W Media, Inc.
4868 Innovation Dr.
Fort Collins, CO 80525
interweave.com

Manufactured in China by RR Donnelley Shenzhen

Library of Congress Cataloging-in-Publication Data

Jurgrau, Andrea.

New vintage lace : knits inspired by the past / Andrea Jurgrau.

 pages cm

Includes bibliographical references and index.

ISBN 978-1-62033-100-2 (pbk.)
ISBN 978-1-62033-117-0 (PDF)

1. Knitting--Patterns. 2. Vintage clothing. 3. Dress accessories. I.

Title.

TT820.J86 2014

746.43'2--dc23

 2013039892

10 9 8 7 6 5 4 3 2 1

Dedication

This book is dedicated to the memory of Rose Levine, my loving grandmother, who taught me how to knit and never seemed to notice when I broke the rules.

Gratitude

I would like to thank my husband, John, and daughter Hallie for their patience and support and for tolerating yarn all over the house and to Hallie, who has been my beautiful model for so long. I would also like to thank my parents, Thelma and David, for always encouraging me and liking everything I ever made.

Many people have helped me along the way, but I thank my test knitting "posse" for always believing in me—every piece in this book was test knitted at least three times, thanks to Cara Baustian, Dawn Gayer, Mary Rose, and Sue Elkind. Thanks to Margaret Carroll, who not only helped with test knitting, but who also stepped in as my business consultant; to Beth Sunderland who helped with test knitting, and to FloraCreate for test knitting and the wonderful Coeur sample!

I thank Sandra Burkett for her support over many years, her never-ending encouragement, and for the great face shot.

Thanks also go to Allison Korleski for giving me this opportunity and to Ann Budd and the entire team at Interweave for their hard work to make this book a reality.

I thank my Thursday evening knitting group and Spin & Eat for fiber friendships that have been long lasting.

Special thanks go to Jane and Ken at Jade Sapphire, for not only yarn but also encouragement and friendship; Bev Elicerio at Land O Lace and Lara Downey at Lara's Creations for their yarn support and friendship; and Crystal Palace, Malabrigo, Manos, Sweet Georgia, Madeline Tosh, Cascade, and Classic Elite for their generous yarn support.

Finally, I thank my feline muse and blocking companion LucyFur; she is gone but not forgotten.

A note about the samples in this book: All samples were knitted by the author except the Couer d'Amour sample worked in Lacey Lamb, which was knitted by FloraCreate.

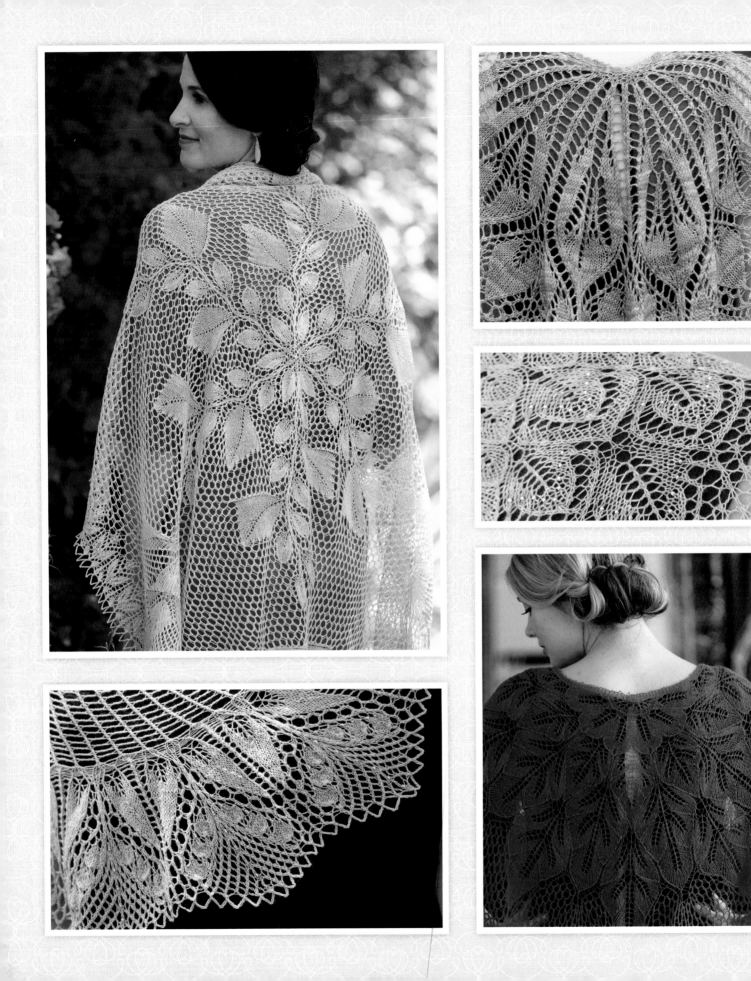

Table of Contents

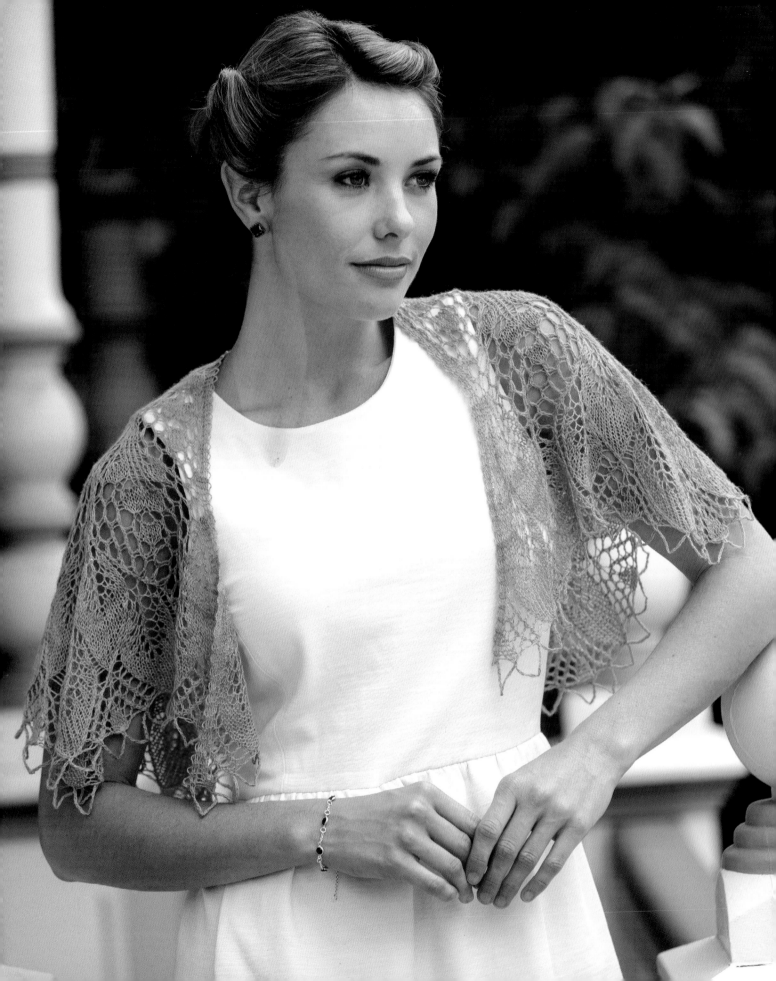

What's Old Is New

This book is about embracing knitting tradition without being bound by it. I can't remember the first time I held knitting needles in my hands, but I do know that my Grandmother Rose taught me to knit and crochet when I was very young. When she was fifteen, she came to America from Eastern Europe with her two younger sisters. As the oldest, she was always the most practical, making useful socks and simple sweaters to keep everyone warm. Her youngest sister, Helen, was the lacemaker. Helen knitted delicate and ornamental sweaters and made intricate doilies. It was her work that always caught my eye.

While in high school, I knitted without patterns, just as my grandmother and great aunts did. I'd never seen a real knitting pattern and had no idea there were any "rules." I'm not sure that much of what I knitted as a child was wearable, but I loved the process. In college, I discovered Elizabeth Zimmermann, and her book *Knitting Without Tears* (Fireside Books, 1973) became the very first knitting book in my collection. *Mary Thomas's Knitting Book* (Dover, 1972) followed close behind.

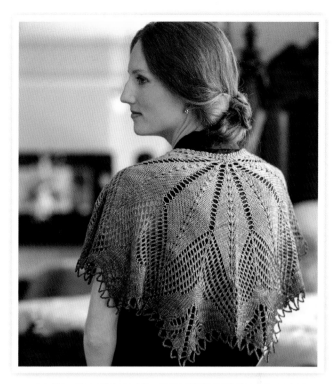

As I got older, I began collecting knitting books and pamphlets, mostly ones with content about traditional styles of knitting. Lace quickly became my favorite. For many years, patterns for the most intricate knitted lace doilies were hard to come by. Only if you were very fortunate, might you find some at a church sale or in your grandmother's knitting bag. As the Internet took off, however, it became possible to find vintage patterns at online auctions, provided you had sufficient luck and money.

Fortunately, large collections of what I consider to be the finest knitted lace doily and tablecloth patterns have become available in the past few years, including those by German designers who knitted during the first half of the twentieth century. This style of lace, called *kunststricken*, translates to "art knitting." Herbert Niebling (1905–1966) is my favorite of these designers. Other lace designers I admire include Marianne Kinzel, Christine Duchrow, and Erich Engeln.

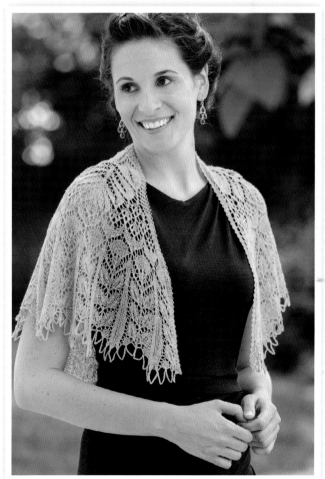

For *New Vintage Lace*, I set out to reinterpret kunststricken for contemporary appeal. Although I take pleasure in knitting doilies and tablecloths, I wanted the projects in this book to attract a wider audience. Maybe I was simultaneously channeling Grandma Rose and her sister Helen when I started envisioning ways to transform these classic lace motifs into wearable pieces for today's lace knitters. Along with detailed directions, you'll also find more general "recipes" that guide you through turning your own inspirations into a hat, scarf, or shawl that's uniquely yours.

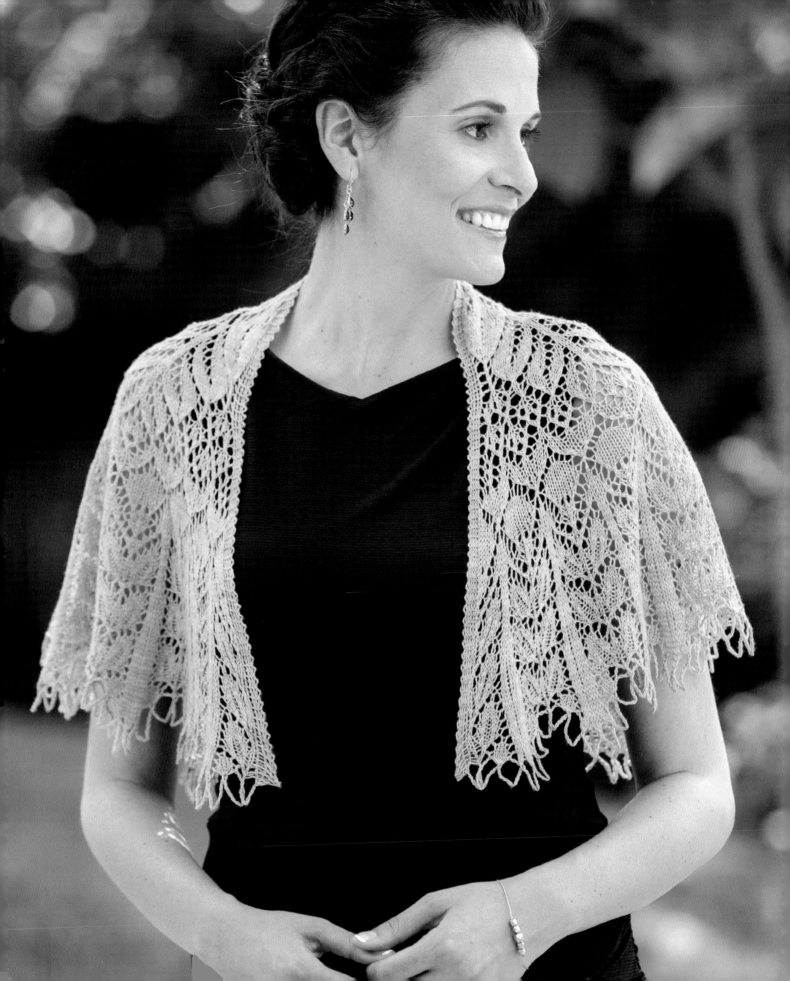

CHAPTER 1
Materials

For me, knitting is a process. It's as much about the creating as it is about the finished product. With that in mind, selecting materials isn't just about the end result, but about the pleasure that comes from the knitting itself. Along with choosing materials appropriate for the end product, choose materials that you'll find pleasurable to work with. Take care in choosing the yarn and beads for each project and you'll find enjoyment from cast-on to bind-off!

Yarn

Happily, lots of yarns on the market are ideal for lace knitting. Many are available from small yarn companies and independent dyers. You'll find a selection listed in the Sources for Supplies on page 140. Hand-dyed yarns come in an infinite assortment of colors and dye techniques, and I delight in using unique yarns whenever I can. The trick in lace knitting is to find the right combination of yarn and pattern.

Choosing just the right yarn for a lace project is a large part of the fun. Lace yarns are available in a huge range of colors, dye techniques, weights, fiber content, and construction, and you'll want to consider all these elements when you make a choice. Each characteristic will contribute to a unique process and end result.

The beauty of knitting lace accessories is that yarn substitutions are relatively easy. Most yarns of similar weight and fiber content will behave the same way as those shown in the projects. Of course, it's always a good idea to knit a generous swatch and block it to make sure that the yarn you've chosen will work well with the pattern. Because most of the projects in this book require less than 800 yards (732 meters), they provide the opportunity for you to experiment with yarn and color choices without too big an investment in money or time.

COLOR

Color is a wonderful thing. It can improve your mood, revive memories, and inspire you. And most of us are quite willing to wear bold colors in a hat, scarf, or shawl that we wouldn't consider for

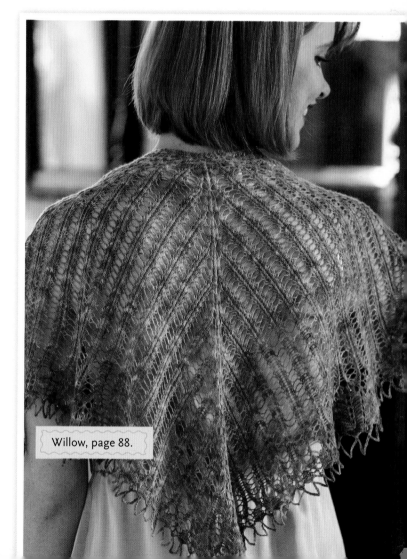

Willow, page 88.

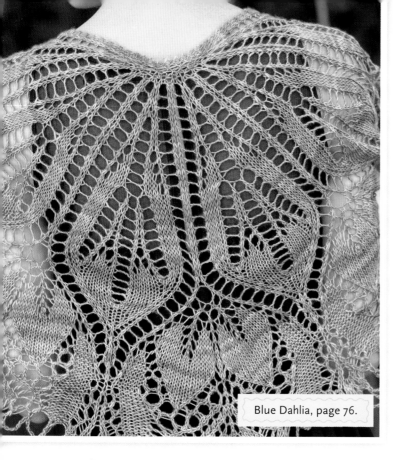

Blue Dahlia, page 76.

WEIGHT

Laceweight yarn can be an acquired taste. Many knitters are initially intimidated by fine, skinny yarn and the corresponding small needles used to knit it. But any lace knitter will tell you that once you develop a taste for skinny yarn, it's hard to go back. Most come to believe that the skinnier the yarn, the better. Consider the pros and cons when deciding what's right for you.

Pros and Cons of Skinny Yarns

Pros	Cons
Skinny yarn allows for more stitches per inch and better "resolution," or detail.	It takes longer to knit skinny yarn, so it takes longer to finish a project.
There are more yards per ounce of skinny yarn, so you get more knitting per skein.	Skinny yarn might be outside your comfort zone.
It takes longer to knit skinny yarns, so you can enjoy the project longer.	The finished piece may be too delicate for everyday use.
Skinny yarns are great for travel knitting because they weigh less and last longer.	

Keep in mind that "laceweight" is a rather generic term that encompasses a wide range of thicknesses. The Craft Yarn Council of America (CYCA) designates any yarn lighter than fingering weight to be laceweight, which the organization designates "0 Lace." This category includes yarns at 600 yards (549 meters)/100 grams to yarns at 1,700 yards (1,554 meters)/100 grams—and right down to sewing thread. When choosing a laceweight yarn, pay attention to how many yards are in 100 grams. If you haven't worked with very fine yarn before, I suggest you begin with one of the heavier yarns in the category, then progress from there. See the box below for a general range in yardages for laceweight yarns.

Typical Yardages Per 100 Grams of Laceweight Yarns

Heavy	600–800 yards (549–732 meters)
Average	800–1,100 yards (732–1,006 meters)
Fine	1,100–1,700 yards (1,006–1,554 meters)
Cobweb	1,700+ yards (1,554+ meters)

an outfit. For example, you might not be comfortable in a fuchsia dress, but a delicate fuchsia scarf may be just what's needed to complete a look.

When you choose a color, consider both the knitting process and the finished object. I always choose colors that I'll enjoy working with as well as wearing. In general, light colors are easier to see as you knit and they show off lace patterns well; solid colors show off lace patterns better than semisolids and tone-on-tone yarns. However, the latter can produce nice effects when used judiciously.

For the most part, I follow the rule that if the stitch pattern is complicated, the yarn shouldn't be. However, if the values or tones of the colors are close, as in the Willow shawl on page 88, and the lace pattern is relatively simple, variegated yarns can add a pleasing visual dimension. If the colors in the yarn are quite different in tone or the values are very different, the yarn may dominate to the point of obscuring the lace pattern.

Tone-on-tone colors can work well, as long as the contrast between the shades isn't distracting. For the Blue Dahlia shawl on page 76, I chose a yarn that has significant color variation, but all the colors are closely related in tone. Because the lace motif is bold, it isn't overpowered by the variegation in the yarn.

Yarns that have long color repeats—the longer the repeat, the better—also can be intriguing, but always knit a swatch to be sure you like the effect. Gradient yarns (those that progress from one color to another through the entire skein) are lovely for lace, as you'll see in Chapter 3.

FIBER CHARACTERISTICS

Laceweight yarns come in a wide range of fiber types. When making a choice, consider the preferences of both you as the knitter and the recipient as the wearer. For example, if you'll be knitting during warm weather, you might want to consider a cooler fiber, such as cotton or linen. If, on the other hand, you'll be knitting during the cold winter months, you might prefer to work with a warm fiber, such as merino, alpaca, cashmere, or kid mohair, that will be comfortable in your lap when the temperatures drop.

Memory is the ability of a fiber to spring back to its original shape after being stretched or blocked. In general, wool has the best memory of all fibers. Cotton and linen lack memory.

Drape is related to memory, in that fibers without memory often have better drape (or flow). Fibers with the best drape include cotton, silk, and linen. Silk is often combined with animal fibers to instill better drape.

Warmth is the ability of a particular fiber to retain heat or insulate. A fluffy yarn (spun in such a way that air is trapped in it) provides more insulation than a tightly spun yarn, and is therefore warmer. Merino, alpaca, cashmere, and kid mohair are all considered "warm" fibers. Silk can be both warm and cool.

Coolness is the opposite of warmth. Cooler fibers do not trap air or retain heat and therefore provide less insulation. Cotton, linen, and silk are considered "cool" fibers.

Halo is the fluffiness that some fibers either begin with or develop after blocking. Kid mohair, which has a very long staple length, has a lovely halo. Alpaca and cashmere also exhibit a halo, but to a lesser degree. The way a yarn is spun will contribute to the halo in the finished yarn.

Crispness is related to a lack of elasticity. Crisp yarns tend to provide excellent stitch definition and are typically cool to the touch. Linen is the classic example of a crisp yarn.

Softness is related to the diameter of the individual fibers. Fibers that are very fine are generally softer than coarser fibers. The finest (and softest) animal fibers are qiviut, cashmere, baby alpaca (and other camelids), and very fine wools (usually merino). The way a particular yarn is spun can also impact its softness.

In general, natural fibers, which can be blocked to reveal the full beauty of lace patterns, are preferable to synthetics, which generally can't. I've used only natural fibers for the projects in this book, and the blocking directions assume that natural fibers have been used.

Typical Fiber Characteristics

Fiber Characteristic	Fine Wool	Silk	Alpaca	Cashmere	Cotton	Linen	Kid Mohair
Memory	●						
Lack of Memory		●		●	●	●	●
Drape		●	●	●	●	●	
Warmth	●	●	●	●			●
Coolness		●			●	●	
Halo			●	●			●
Crispness		●			●	●	
Softness	●	●	●	●	●		●

YARN CONSTRUCTION

Too often, knitters don't give much, if any, thought to how a yarn is constructed when they select yarn for a project. But yarn construction can have a significant effect on the longevity of the finished piece. For example, a baby blanket will be subjected to a lot of wear and have to withstand many washings, whereas a wedding shawl will undergo minimal handling. A yarn with multiple plies will be sturdier and less likely to show wear than a singles. Fibers with long staple lengths (the length of individual fibers), such as some wools, silk, and kid mohair, are less likely to pill than those with short staple lengths, such as cotton and cashmere. In addition, yarns that are more tightly spun will be less likely to pill than those that are loosely spun.

Beads

In general, I include beads to add a little elegance to my projects. However, I use beads in moderation, and I typically avoid sharp contrast between the yarn and beads. In some cases, you might not even notice the beads on first glance. But once noticed, you'll appreciate the extra *je ne sais quoi* that they contribute. Beads also add some weight, which adds to the overall drape. It's perfectly fine to omit the beads, but before you decide that they're not for you, at least give them a try!

Beads come in a myriad of colors and finishes that will match every yarn. Take your yarn with you when you shop for beads so you're sure to choose just the right color. When you select beads, don't skimp on quality. Quality beads are more uniform both in outer circumference and hole size—which tends to be larger and therefore easier to work with—than inexpensive beads. Look for beads that have permanent finishes. Beads that are simply dyed can fade or bleed onto the yarn when wet, and you should avoid them. If you're unsure about colorfastness, use the bead in a knitted swatch, then wash it. Although I enjoy using all sorts of beads, I tend to favor Japanese seed beads for their uniform quality.

If your project includes beads, you'll need a large-eye needle or floss threader for threading the beads onto your yarn, or you'll need a small crochet hook to slip the beads onto stitches.

Bead Finishes

Color-lined	lined with a colored coating
Metal-lined	lined with a metallic coating, often silver or gilt (gold)
AB (Aurora Borealis)	an iridescent surface finish
Iris	similar to AB with assorted hues
Rainbow	similar to AB
Luster	shiny finish that is slightly pearl-like
Gold Luster	shiny finish with a metallic/golden glow
Ceylon	opaque, solid pearl-like finish
Opaque	opaque, solid color
Transparent	allows color to show through
Matte	dull finish
Permanent Galvanized	metallic plated
Opal	semitranslucent with a nice glow

Take into account how the beads will be used in a particular design when selecting the type of bead finish. If the beads will be used to outline and define lace motifs, choose a shiny finish that will contrast with the yarn. If the beads are to add subtle weight without distracting from the lace pattern, you may prefer a matte finish.

The bead sizes specified for the projects in this book are based on the specified yarn. If you decide to substitute a different yarn, be sure to check that bead size doesn't have to change accordingly. In general, an 8/0 bead works for heavy and average laceweight yarn; a 10/0 (or even 12/0) works for finer laceweights. If you decide to use a different-size bead, you'll also need to adjust the number of grams needed—there are fewer 6/0 beads than 8/0 beads in a gram!

Beads come in a variety of shapes—round (called seed beads), square, hexagonal, and triangular—all of which reflect the light differently. It's always best to swatch a few before deciding which is best for your project.

Seed Bead Sizes

6/0	3.3mm
8/0	2.5mm
10/0	2mm
11/0	1.8mm
12/0	1.7mm
15/0	1.3mm

Steel Crochet Hook Sizes

U.S.	Metric	U.K.
00	3.5 mm	
0	3.25 mm	0
1	2.75 mm	1
2	2.25 mm	1½
3	2.1 mm	2
4	2 mm	2½
5	1.9 mm	3
6	1.8 mm	3½
7	1.65 mm	4
8	1.5 mm	4½
9	1.4 mm	5
10	1.3 mm	5½
11	1.1 mm	6
12	1 mm	6½
13	0.85 mm	7
14	0.75 mm	

Needles and Crochet Hooks

The tools you select are critical to the ease and success of your knitting. Many types of needles are available, and most knitters have their favorites. But when it comes to lace knitting, I recommend tapered, pointy tips and, for circular needles, very smooth joins and flexible, smooth cables.

To apply beads, you'll need a steel crochet hook that's small enough to fit through the bead and large enough to grab the yarn and bring it back through the bead. The best way to be sure you have the correct hook is to try it with your yarn and bead. Keep in mind that while hook sizes are inconsistent from manufacturer to manufacturer, the sizes reported in millimeters are most reliable. I've found that a 0.6–0.75 mm steel hook works well for size 8/0 beads and average laceweight yarn.

Blocking Wires and Pins

I use blocking wires for all my lace pieces. Wires come in lengths ranging from 12" (30.5 cm) to 60" (152.5 cm), and they can be rigid or flexible. I specify the type I used for each project. But keep in mind that there are multiple ways to block pieces.

Of the many types of blocking pins, I prefer stainless steel T-pins that don't run the risk of developing rust, which can stain yarn. Be sure to use pins with smooth tips. As pins get older, burrs can develop on the tips that can snag the yarn. Such pins should be replaced.

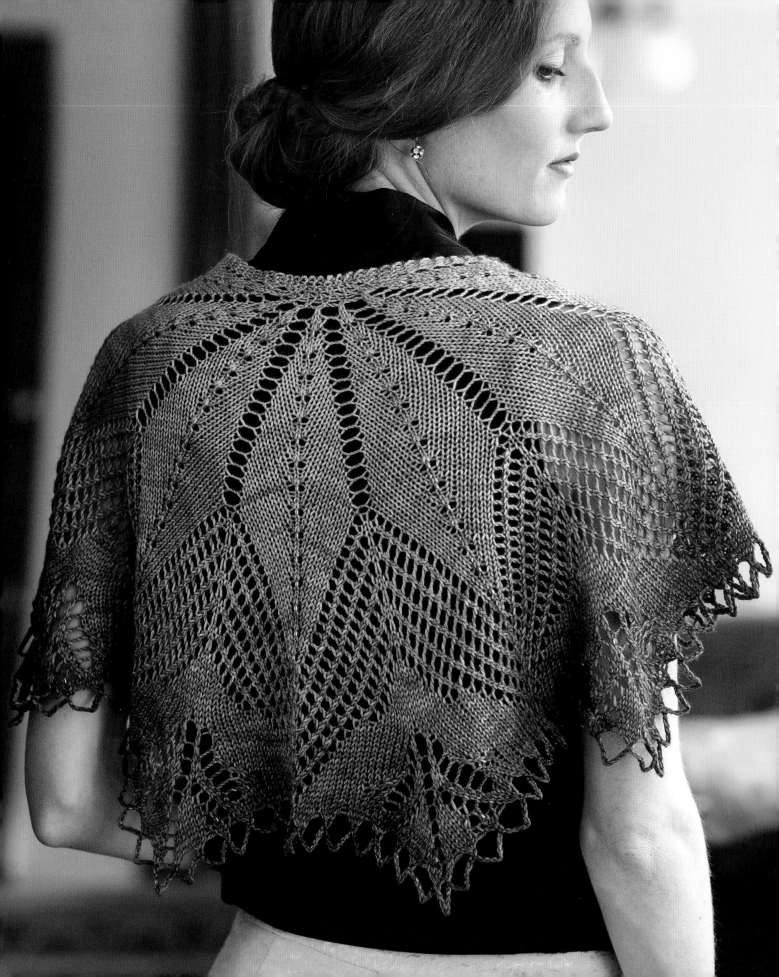

CHAPTER 2:
Techniques

The following techniques, listed in alphabetical order, are essential for the successful outcome of the projects in this book. Take a few minutes to read all the way through this chapter to become familiar with them.

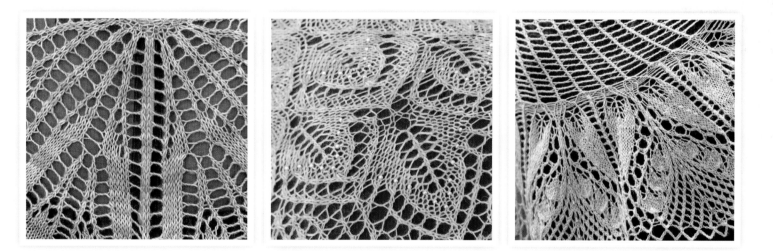

Beads

I add beads to many of my lace projects, mostly because I enjoy knitting with them and experimenting with different combinations of beads and yarn. In general, there are two ways to add beads to knitting—use a crochet hook to apply the bead directly on the stitch where it's needed or prestring the beads on your yarn and then move them into place between stitches as desired. The two techniques are not interchangeable.

APPLYING BEADS WITH A CROCHET HOOK

This method allows precise placement of the bead in an individual stitch and is the method used for most of the projects in this book. Although it's easier to put the bead on the stitch before it is knitted, so doing can compromise the tension on that stitch.

Work to the stitch designated for bead placement, work the stitch as specified in the instructions, slip a bead onto the shaft of a crochet hook, remove the knitted stitch from the knitting needle, and lift the stitch just worked with the hook (**Figure 1**). Slide the bead onto the stitch just worked, return that stitch to the left needle, adjust the tension, then slip that stitch onto the right knitting needle (**Figure 2**).

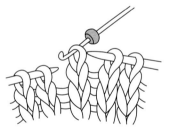

FIGURE 1

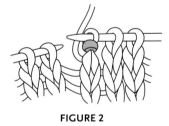

FIGURE 2

PRESTRING THE BEADS ONTO WORKING YARN

This method suspends the beads between two stitches or at a selvedge. It cannot be substituted for applying beads with a crochet hook.

Before casting on, use a large-eye needle or dental floss threader to string the required number of beads onto the yarn (**Figure 1**), pushing them down far enough to let you work with the yarn alone. Following the pattern (purl stitches shown here), slide a bead between two stitches as specified (**Figure 2**).

Keep in mind that friction is involved as you slide the beads into place as you work. The more beads that are prestrung, the more potential there is for damaging the yarn. I don't prestring more than 4' to 5' (1.2 to 1.5 meters) of beads, which requires a fair amount of patience to advance them without breaking the yarn.

FIGURE 1

FIGURE 2

Bind-Offs

A loose bind-off is critical for proper lace blocking. Both of the methods listed here will provide a sufficiently loose edge. The project instructions will specify which type to use.

GATHERED CROCHET BIND-OFF

See page 21 for crochet instructions.

Insert hook through the back legs of the specified number of stitches (**Figure 1**; three stitches shown) to gather them, pull a loop through so there is one loop on the hook (**Figure 2**), work a crochet chain the specified length (**Figure 3**; eight stitches shown), *insert the crochet hook through the back legs of the next group of stitches (**Figure 4**), pull the yarn loop through these stitches as well as through the stitch of the chain (**Figure 5**), and work a crochet chain for the specified number of stitches; repeat from *.

If working in rounds, finish by joining the final chain to the base of the first gathered group, then pull the yarn through the final loop, leaving a 9" (23 cm) tail.

If working in rows, finish by pulling the loop through the final group of stitches, then pulling the yarn through the final loop, leaving a 9" (23 cm) tail.

LACE BIND-OFF

This smooth and stretchy method is ideal for edges that will be stretched during blocking. Be sure to work loosely but evenly; use a needle one or two sizes larger than you knit with if desired.

Slip one stitch, knit one stitch, *insert the left needle tip into the front of both of these stitches and knit them together through the back legs (**Figure 1**), return resulting stitch to the left needle tip; repeat from * until all stitches have been worked and one stitch remains on right needle. Cut yarn, leaving a 9" (23 cm) tail, bring the tail through the remaining stitch and pull tight to secure.

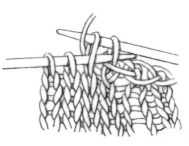

Blocking

Blocking may be the most critical step in a lace project. Just off the needles, a lace project can look like a worn-out rag. Only through blocking will its full beauty be revealed. I always wet-block my lace by soaking it in cool water for at least 30 minutes (perhaps longer for silk) so that the fibers are thoroughly wet, pressing the project down into the water a few times as it soaks to ensure uniform water penetration. If desired, you can add a mild soap to gently wash the piece at this time, but be careful to rinse it well to remove the soap.

Press out the excess water with your hands and then roll the piece in a thick towel to remove the extra water. Lay it on a flat padded surface and use wires and T-pins to block as directed in the pattern. Allow it to air-dry completely before removing the blocking wires and pins. I generally weave in the loose ends before I block a piece, but I don't trim the remaining tails until after it has completely dried.

It's important to note that the dimensions of the knitting right off the needles will be considerably smaller than after the piece has been stretched during blocking. It's equally important to note that the blocked dimensions are the maximum dimensions the piece will measure—most will relax a little with handling.

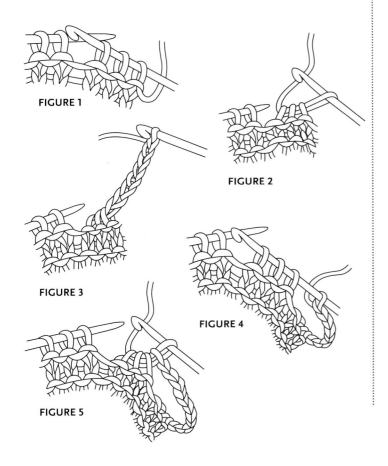

FIGURE 1

FIGURE 2

FIGURE 3

FIGURE 4

FIGURE 5

Cast-Ons

CIRCULAR CAST-ONS

Several of the pieces in this book are worked outward from the center and require a circular cast-on.

Emily Ocker's Circular Cast-On

I learned this method from Elizabeth Zimmerman's *Knitter's Almanac* (Dover Publications, 1981).

Make a simple loop of yarn with the short end hanging down. With a crochet hook, *draw a loop through the main loop, then draw another loop through this loop. Repeat from * for each stitch to be cast on. Divide the stitches evenly on four double-pointed needles.

After several inches of the pattern have been worked, pull on the short end to tighten the loop and close the circle.

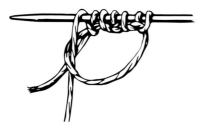

Marianne Kinzel's Method

This method comes from Marianne Kinzel's *First Book of Modern Lace Knitting* (Dover Publications, 1972). It's especially good when using fine yarn.

You'll need a set of five double-pointed needles in the size needed for the specified gauge and a crochet hook that's close to the same size as the knitting needles. See page 21 for crochet instructions.

With the crochet hook, make a crochet chain the specified number of stitches long (**Figure 1**; eight stitches shown),

then use a slip stitch to join the chain into a loop (**Figure 2**). Work a single crochet into each of the next three chain stitches (four stitches on the crochet hook), divide these four stitches evenly on two double-pointed needles, work a single crochet into each of the next four chain stitches (again four stitches on crochet hook; **Figure 3**), then divide these four stitches evenly on two other double-pointed needles (**Figure 4**).

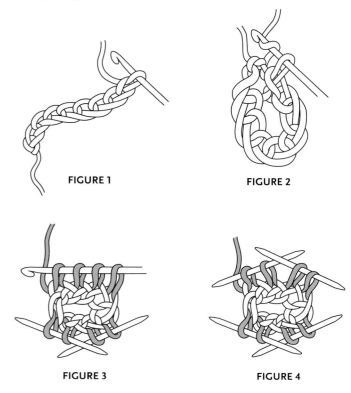

FIGURE 1

FIGURE 2

FIGURE 3

FIGURE 4

Long-Tail Method

Although the long-tail method is hard to use with very fine yarn, it works well with average or heavy laceweight yarn if there are six or more stitches. I use this method most frequently.

Simply use the long-tail method as described on page 19 to cast on six or more stitches, then divide the stitches onto needles for working in rounds. Join, being careful not to twist the stitches.

PROVISIONAL CAST-ON

Many of the pieces in this book begin with a provisional cast-on. This allows for an elastic edge and seamless pick-up of new stitches.

Invisible Provisional Cast-On

Make a loose slipknot of working yarn and place it on the right needle tip. Hold a length of contrasting waste yarn (of about the same diameter as the working yarn) next to the slipknot and around your left thumb; hold the working yarn over your left index finger. ✷Bring the right needle forward under the waste yarn, over the working yarn, grab a loop of working yarn (**Figure 1**), then bring the needle back behind the working yarn and grab a second loop (**Figure 2**). Repeat from ✷ for the desired number of stitches. When you're ready to work in the opposite direction, carefully pull out the waste yarn as you place the exposed loops onto a knitting needle.

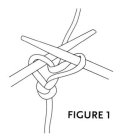

FIGURE 1

FIGURE 2

STRETCHY CAST-ONS

Because lace needs blocking to really show its beauty, you need a nice stretchy cast-on.

Knitted Cast-On

Make a slipknot of working yarn and place it on the left needle tip. ✷Insert the right needle tip knitwise into the slipknot, wrap the yarn around the needle as if to knit, and pull the loop through (**Figure 1**). Keeping the slipknot on the left needle tip, place the new loop onto the left needle in front of it to form a new stitch (**Figure 2**). Repeat from ✷, always working into the last stitch made (only work into the slipknot for the first stitch).

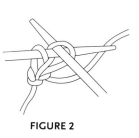

FIGURE 1

FIGURE 2

Long-Tail Cast-On

To ensure that this cast-on is suitably stretchy, I work this method over two needles of the size needed to get gauge.

Leaving a long tail (about ¼" [6 mm] per stitch), make a slipknot and place it on the right needle tip. Place the thumb and index finger of your left hand between the yarn ends so that the working yarn is around your thumb. Secure both yarn ends with your other fingers. Hold your palm upward, making a V of yarn (**Figure 1**). ✷Bring the needle up through the loop around your thumb (**Figure 2**), catch the first strand around your index finger, and bring the needle back down through the loop on your thumb (**Figure 3**). Drop the loop off your thumb and place your thumb back in the V configuration while tightening the resulting stitch on the needle (**Figure 4**). Repeat from ✷ for the desired number of stitches.

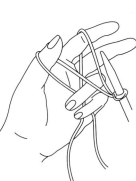

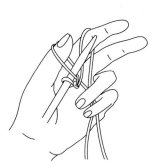

FIGURE 1

FIGURE 2

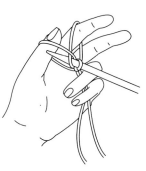

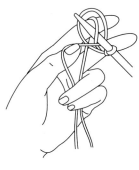

FIGURE 3

FIGURE 4

Cable Cast-On

Make a slipknot of working yarn and place it on the left needle tip. Insert the right needle tip into the slipknot knitwise, wrap the yarn around the needle as if to knit, and pull the loop through (**Figure 1**). Keeping the slipknot on the left needle tip, place the new loop onto the left needle in front of the slipknot to form a new stitch (**Figure 2**). *Insert the right needle between the first two stitches on the left needle (**Figure 3**), wrap yarn around the needle as if to knit, draw the yarn through (**Figure 4**), and place the new loop on the left needle (**Figure 5**) to form a new stitch. Repeat from *, always working between the first two stitches on the left needle.

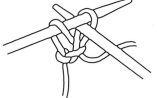

FIGURE 1

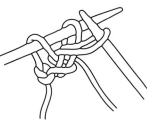

FIGURE 2

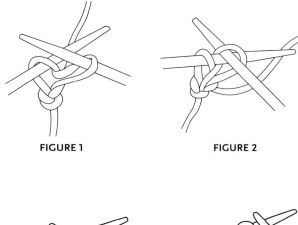

FIGURE 3 **FIGURE 4**

FIGURE 5

Charts

If you're new to reading charts, don't be intimidated. Charts represent the knitted fabric in a very logical way. Each symbol is designed to represent how the stitches will appear (when viewed from the right side) after they've been worked. For example, a right-leaning decrease is represented by a right-leaning symbol on the chart; a yarnover, which forms an open eyelet, is represented by an open circle on the chart. Charts will help you learn to read your knitting, and as you get better at reading your knitting, charts will become easier. As you gain experience with both, you'll learn to recognize mistakes and fix them quickly. Start with the simpler projects and practice comparing what's on your needles with what's shown in the chart. The sidebar below gives general rules for working with charts.

To help keep your place on a chart, it's a good idea to mark the row being worked. For charts in which there are no row repeats, my favorite technique is to make a photocopy of the chart and use a highlighter to color each row as I complete it. Not only does this mark my place, it also allows me to compare the row I'm working on with those I've already completed. If the chart involves a series of rows that are repeated (outlined in red), the highlighter method only works for the first repeat. In these cases, I fix removable highlighter tape to the row being worked, and I move the tape up the chart as I progress from row to row. This allows me to start afresh with the first row of each repeat.

General Rules for Following Charts

Review the key before you begin to make sure you understand the meaning of each symbol.

Read charts from the bottom to the top. Each row on the chart represents one row or round of knitting; each cell in the chart indicates one stitch.

When working back and forth in rows, right-side (RS) rows, which are numbered, are read from right to left; wrong-side (WS) rows are read from left to right.

When working in rounds, all chart rows are considered right-side (RS) rows, and all are read from right to left.

Many charts include "no stitch" symbols—gray cells instead of designated stitch symbols. These "no stitch" symbols are used as placeholders in the chart

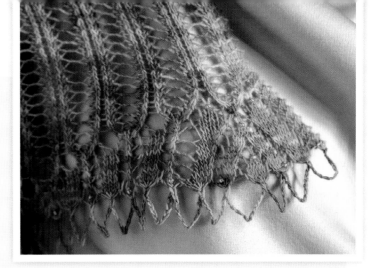

so that increases, decreases, and yarnovers align in the chart as they will in your knitting. When you come to a "no stitch" symbol, simply skip over it and continue with the next "real" stitch on the chart.

Bold red and blue outlines indicate stitches and rows that are repeated. For example, when working a right-side row or round, work to the right edge of the repeat outline, then repeat the stitches within the outline the necessary number of times, then finish by working the stitches from the left of the outline to the edge of the chart.

Willow Chart A

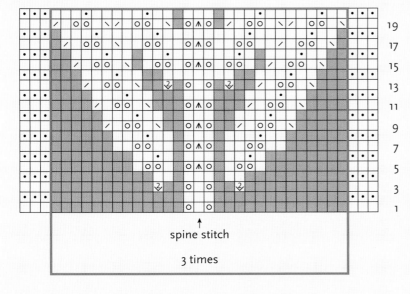

spine stitch

3 times

☐	knit on RS, purl on WS
•	purl on RS, knit on WS
○	yo
⤵	[k1, p1] in same stitch
⋀	s2kp
⟍	ssk
⟋	k2tog
▨	no stitch
☐	pattern repeat

Crochet

CROCHET CHAIN (CH)

*Yarn over hook and draw through a loop on hook. Repeat from * for the desired number of stitches.

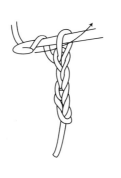

SINGLE CROCHET (SC)

*Insert hook into the next stitch, yarn over hook and draw through a loop, yarn over hook (**Figure 1**), and draw it through both loops on hook (**Figure 2**). Repeat from * for the desired number of stitches.

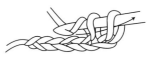

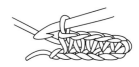

FIGURE 1 **FIGURE 2**

SLIP-STITCH CROCHET (SL ST)

*Insert hook into stitch, yarn over hook and draw a loop through both the stitch and loop already on the hook. Repeat from * for the desired number of stitches.

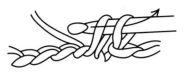

Decreases

DOUBLE DECREASES

Centered Double Decrease (s2kp)

This type of decrease has a vertical alignment.

Slip two stitches together knitwise (**Figure 1**), knit the next stitch (**Figure 2**), then pass the slipped stitches over the knitted stitch (**Figure 3**)—two stitches decreased.

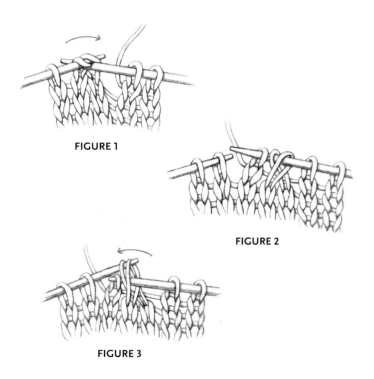

FIGURE 1

FIGURE 2

FIGURE 3

Knit 3 Together (k3tog)

This type of decrease slants to the right.

Knit three stitches together as if they were a single stitch—two stitches decreased.

Purl 3 Together (p3tog)

Purl three stitches together as if they were a single stitch.

Slip, Slip, Slip, Knit (sssk)

This type of decrease slants to the left.

Slip three stitches individually knitwise, insert the left needle tip into the fronts of these three slipped stitches, then use the right needle to knit them together through their back loops—two stitches decreased.

FIGURE 1

FIGURE 2

SINGLE DECREASES

Knit 2 Together (k2tog)

This type of decrease slants to the right—one stitch decreased.

Knit two stitches together as if they were a single stitch.

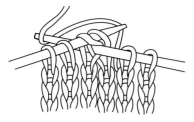

Knit 2 Together Through Back Loops (k2togtbl)

This type of decrease slants to the left.

Insert the right needle tip into the back loops of the next two stitches on the left needle, wrap the yarn around the needle, then pull a loop through while slipping the stitches off the left needle.

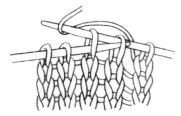

Purl 2 Together (p2tog)

This type of decrease slants to the right.

Purl two stitches together as if they were a single stitch.

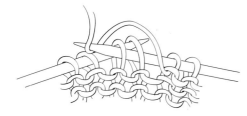

Slip, Slip, Knit (ssk)

This type of decrease slants to the left.

Slip two stitches individually knitwise (**Figure 1**), insert the left needle tip into the front of these two slipped stitches, and use the right needle to knit them together through their back loops (**Figure 2**)—one stitch decreased.

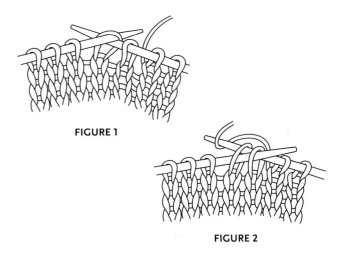

FIGURE 1

FIGURE 2

Increases

YARNOVER

The way that a yarnover is worked depends on what type of stitch (knit or purl) has just been worked and the type of stitch (knit or purl) that will be worked next.

After a Knit and Before a Purl

Beginning with the working yarn in the back of the needles, bring the yarn to the front of the work between the needles, then over the right needle and again to the front, ready to purl the next stitch.

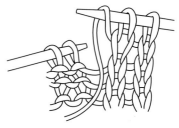

After a Purl and Before a Knit

Beginning with the working yarn in front of the needles, bring the yarn over the right needle to the back, ready to knit the next stitch.

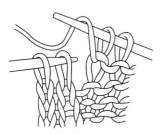

Between Two Knit Stitches

Beginning with the yarn in the back of the needles, bring the yarn to the front of the work between the needles, then over the right needle to the back, ready to knit the next stitch.

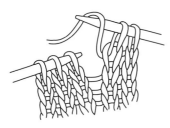

Between Two Purl Stitches

Beginning with the working yarn in front of the needles, bring the yarn over the top of the right needle to the back, then between the two needles to the front, ready to purl the next stitch.

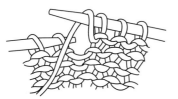

Double Yarnover

Wrap the yarn twice around the needle as described above. On the return row or round, work the two loops as purl 1, knit 1.

When you work in rounds and a double yarnover spans the end-of-round marker (one yarnover is at the beginning of the round and the other is at the end of the same round), you'll need to work them together (either at the beginning or the at the end of the round) to maintain pattern consistency. I prefer to work them at the beginning of the round by working a double yarnover at the beginning of the round and omitting the yarnover at the end of the round. On the next round, I remove the end-of-round marker, purl the first yarnover, replace the marker, then knit the second yarnover.

Make-One Without Twist (M1)

This forms a smaller hole than a regular yarnover. It is worked as a make-one increase but without twisting the horizontal strand.

Use the left needle tip to lift the strand between the needle tips from front to back (**Figure 1**), then knit the lifted loop without twisting it—one stitch increased.

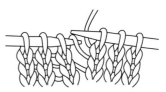

MAKING MULTIPLE STITCHES (\3/)

Alternate knitting and purling into the same stitch the specified number of times. If the number is 3, then knit 1, purl 1, knit 1 into the same stitch. If the number is 4, then knit 1, purl 1, knit 1, purl 1 into the same stitch, and so on.

Joining Yarn

When knitting lace, it's best to join a new ball of yarn as inconspicuously as possible.

Russian Join

This type of join works well with all types of yarn and is especially good when changing colors.

Thread the smallest needle possible with a 4" (10 cm) tail of the old yarn. Make a loop by inserting the needle back

through the plies of the same yarn for about 1" (2.5 cm), then let the tail hang free, leaving a loop at the fold. Thread the end of the new yarn onto the needle, bring it through the loop in the old yarn, then insert it inside the plies of the new yarn in the same way to connect the two loops (**Figure 1**). Pull the loose ends to tighten the loops (**Figure 2**). Trim the remaining tails.

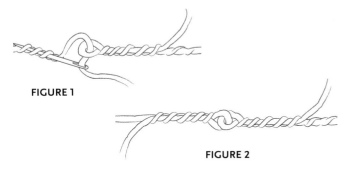

FIGURE 1

FIGURE 2

Spit Splicing

This method works only with feltable yarns such as wool and alpaca. It doesn't work for superwash wool, cotton, silk, or linen.

Untwist the plies from both the old and new ends of yarn for about 2" (5 cm) (**Figure 1**), moisten the loose ends with saliva, overlap the loose ends (**Figure 2**), then rub them vigorously between your palms (**Figure 3**). The moisture and friction will cause the two yarn ends to felt together.

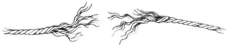

FIGURE 1

FIGURE 2

FIGURE 3

Pick-Up Stitches

Pick Up and Knit

With right side facing and working from right to left, *insert the needle tip under the edge stitch (**Figure 1**), wrap the yarn around the needle, and pull through a loop (**Figure 2**). Repeat from * for the desired number of stitches.

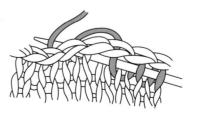

FIGURE 1

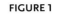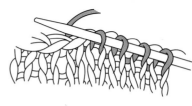

FIGURE 2

Pick Up and Purl

With wrong side of work facing and working from right to left, *insert needle tip under edge stitch from the far side to the near side (**Figure 1**), wrap yarn around needle, and pull through a loop (**Figure 2**). Repeat from * for the desired number of stitches.

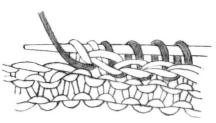

FIGURE 1

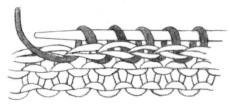

FIGURE 2

Shift the Beginning of a Round

Some patterns that are worked in rounds require that the beginning-of-round marker be shifted to the left or right on specific rounds; the charts for such patterns are clearly labeled. If the shift is to the left, just work the required number of stitches past the end of the round, then relocate the marker and resume with the first stitch of the next round. If the shift is to the right, stop working the required number of stitches before the end of the round, relocate the marker to this position, then continue with the first stitch of the next round.

Stitch Markers

Except to mark the beginning of the round when working in rounds (and many times I simply refer to the cast-on tail instead of using a marker), I only use stitch markers for very specific situations. Although some designers advocate placing a marker at the end of every pattern repeat, the markers get in the way if the pattern repeat straddles a double decrease or if the beginning of the round shifts from one position to another. In addition to the beginning-of-round marker, every other marker would have to be shifted accordingly in these cases. For example, if the instructions say to move the beginning of the round one stitch to the left, all the other markers will have to shift one stitch to the left as well.

When I do use markers, I choose smooth, thin markers that won't snag delicate yarn or affect the neighboring stitches. Otherwise, telltale "ladders" may appear in the finished piece. I also prefer markers that dangle a bit so that they won't inadvertently slip through yarnovers. Some of my favorite markers are ones that I've made from crochet cotton. I cut crochet cotton that's finer than my working yarn into 3" (7.5 cm) lengths, fold the lengths in half, then tie an overhand knot about halfway up the doubled thread to make a loop that's about ¾" (2 cm) long with ¾" (2 cm) tails.

Seams

Overhand Stitch

Bring a threaded needle down front to back through fabric on one side of seam, then up from back to front on the other side; repeat from *, striving for even spacing of the stitches.

Stitches

In addition to knits and purls, the following stitches are used in many of the projects in this book

BASIC STITCHES

Twisted Knit (k1tbl)

Insert the right needle through the loop on the back of the left needle from front to back (**Figure 1**), wrap the yarn around the needle, and pull a loop through while slipping the stitch off the left needle (**Figure 2**). This stitch is similar to a regular knit stitch, but it's worked into the back loop of the stitch instead of the front.

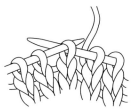

FIGURE 1

FIGURE 2

Twisted Purl (p1tbl)

Insert the right needle through the loop of the back of the left needle from back to front (**Figure 1**), wrap the yarn around the needle, and pull a loop through while slipping the stitch off the left needle (**Figure 2**). This stitch is similar to a regular purl stitch, but it's worked into the back loop of the stitch instead of the front.

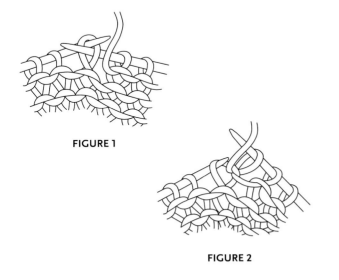

FIGURE 1

FIGURE 2

SELVEDGE STITCHES

Many knitters like to work a selvedge by slipping the first stitch of every row. However, I believe that slipped selvedge stitches are less elastic than knitted (or purled) stitches and can inhibit full blocking of a lace piece. Blocking is critical for all of the projects in this book and shouldn't be compromised by tight edges.

SPECIAL STITCHES

Nupps

Nupps are small bobbles that have their roots in Estonian knitting.

With the right side of the work facing, work to the desired nupp stitch. Working very loosely, knit into the designated stitch, but leave that stitch on the left needle. *Yarnover, then knit the stitch again (**Figure 1**); repeat from * until the desired number of loops are on the needle (typically seven or nine), ending by knitting into the stitch again to secure the last yarnover (**Figure 2**; seven nupp loops shown). If working in rows, purl the seven or nine nupp loops together on the following wrong-side row (**Figure 3**; p7tog shown). If you work in rounds, knit the seven or nine nupp loops together through their back loops on the following round.

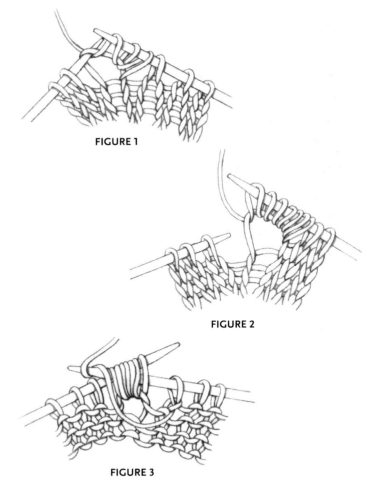

FIGURE 1

FIGURE 2

FIGURE 3

CHAPTER 3:
The Fine Art of Swatching

To swatch or not to swatch? That's every knitter's question, and many lace knitters like to think that swatching is optional because fit really isn't an issue with scarves and shawls. However, even if you're not concerned about fit, there are good reasons to swatch. First, swatching will help you decide if you've chosen the correct yarn for your project. This isn't an issue if you use the yarn specified in the project, but if you plan to substitute a different yarn, you can't be sure to get similar results. The only way to know for sure is to knit a swatch of the pattern and block it. Doing so will also give you the opportunity to decide if you've chosen the best needle size.

A second, very critical reason to swatch is to make sure you'll have enough yarn to complete the project. If you use the same yarn as specified, but knitted at a different gauge, you'll likely end up needing a different amount of yarn. If you get fewer stitches to the inch than specified in the pattern, you'll need more yarn; if you get more stitches to the inch, you'll need less. You certainly don't want to run out of yarn before you bind off the last stitch! Enough said.

Through swatching, you can be sure to choose just the right yarn for your project. You can sample yarns with different colors, dye techniques, fibers, or textures in a relatively small swatch before you invest in the full project. And who says a swatch can't be a sweet project all on its own?

I've provided charts in this chapter for swatching in rounds and in rows. Keep in mind that your gauge can be very different when working in rounds, in which you're always working on the right side, than when working in rows, in which you alternate between right- and wrong-side rows. It's therefore important to swatch in the same manner that you'll knit your piece.

Circular Swatch

Use the Circle Swatch Chart to practice techniques and check your gauge for the projects in this book that are worked in rounds. This type of project is worked from the center outward.

This swatch includes a circular cast-on, working in rounds, twisted stitches, a variety of decreases, and a crochet bind-off.

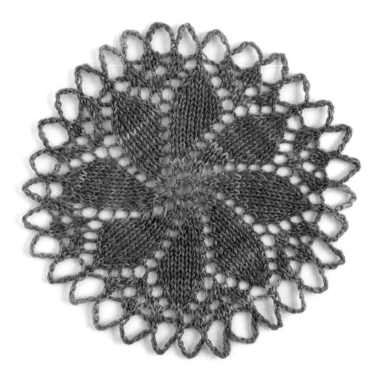

MATERIALS

- ❀ About 50 yards (45.7 meters) of any sock-weight yarn that contains at least some wool (alternatively, use your project yarn, then reclaim it if you need it)

- ❀ Set of five size U.S. 3 (3.25 mm) double-pointed needles, or the size suggested in the pattern

- ❀ Size 1 (2.75 mm) steel crochet hook

- ❀ Stitch marker (optional)

- ❀ Tapestry needle

- ❀ Blocking pins

CIRCLE

With a double-pointed needle, use the long-tail method (see page 19) to cast on 8 stitches. Divide the stitches onto four double-pointed needles so that there are 2 stitches on each needle. Place a marker and join for working in rounds, being careful not to twist the stitches.

Knit 1 rnd.

Work Rows 1–22 of Circular Swatch Chart, repeating each row of chart 8 times per round—96 sts.

Use the gathered crochet method (see page 17) to bind-off all stitches as follows: *gather 3 stitches, chain 6; repeat from * until no stitches remain.

Use a slip stitch to secure the final chain loop to the first group of gathered stitches.

Cut the yarn, leaving a 9" (23 cm) tail. Pull tail through remaining loop to secure.

FINISHING

Weave in loose ends on wrong side, but do not trim the tails.

Soak in cool water until fully wet, then roll in towel to remove extra water.

Lay flat to dry, pinning out each crochet loop so that piece is about 8" to 9" (20.5 to 23 cm) in diameter.

Allow to air-dry completely before removing pins and trimming tails.

Circle Swatch Chart

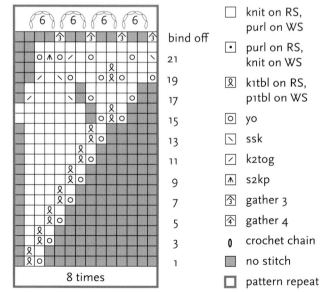

Symbol	Meaning
□	knit on RS, purl on WS
•	purl on RS, knit on WS
⅋	k1tbl on RS, p1tbl on WS
O	yo
＼	ssk
／	k2tog
⅄	s2kp
③	gather 3
④	gather 4
0	crochet chain
▨	no stitch
□	pattern repeat

Triangular Swatch

Use the Triangle Swatch chart to practice techniques and check your gauge for the shawls in this book that are worked back and forth in rows. This type of shawl is worked downward from the center of the long edge.

This swatch includes a provisional cast-on, twisted stitches, double yarnovers, and a crochet bind-off.

MATERIALS

- ✾ About 50 yards (45.7 meters) of any sock-weight yarn that contains at least some wool (alternatively, use your project yarn, then reclaim it if you need it)

- ✾ 12" (30.5 cm) of waste yarn for provisional cast-on

- ✾ Size U.S. 3 (3.25 mm) 16" (40 cm) circular needle, or the size suggested in the pattern

- ✾ Size 1 (2.75 mm) steel crochet hook, or the size suggested in the pattern

- ✾ Stitch markers (optional)

- ✾ Tapestry needle

- ✾ Blocking pins and a short rigid blocking wire

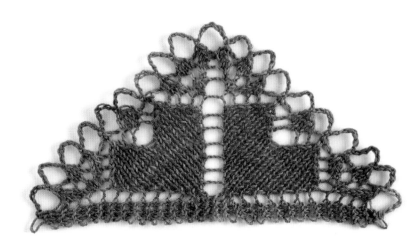

TRIANGLE

With circular needle, use a provisional method (see page 19) to cast on 3 stitches.

Knit 11 rows but do not turn the work after the last row—5 garter ridges when viewed from the right side.

Rotate the work 90 degrees and, working into each garter bump, pick-up and purl (see page 25) 4 stitches along one selvedge.

Carefully remove the waste yarn from the provisional cast-on and knit the 3 exposed stitches—10 stitches total.

Knitting the first 3 and last 3 stitches of every row, work the center 4 stitches according to Rows 1–22 of Triangle Swatch Chart—62 stitches.

Use the gathered crochet method (see page 17) to bind-off all stitches as follows: gather 3, chain 6, *[gather 3 stitches, chain 6] 4 times, gather 4, chain 6, [gather 3, chain 6] 4 times; repeat from * once, gather 3.

Cut the yarn, leaving a 9" (23 cm) tail. Pull tail through remaining loop to secure.

FINISHING

Weave in loose ends on wrong side, but do not trim the tails.

Soak in cool water until fully wet, then roll in towel to remove extra water.

Lay flat to dry, pinning out each crochet loop so that piece measures about 9" (23 cm) along the straight edge.

Allow to air-dry completely before removing pins and trimming tails.

Triangle Swatch Chart

Swatching for Yarn Choice

I knitted several circular swatches to demonstrate how yarn choice can affect lace patterns. All of the following swatches were worked with sock (fingering-weight) yarn, following the Circle Swatch chart on page 30.

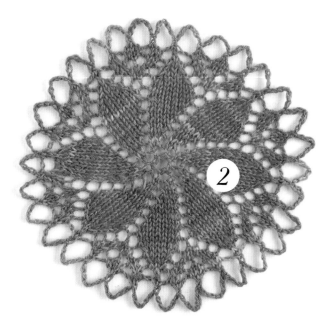

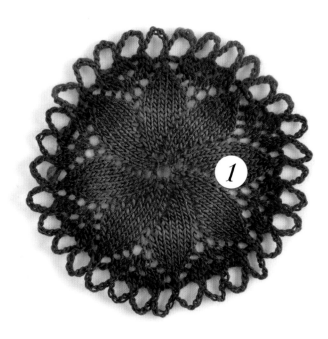

Swatch 1. I particularly like the way that very long color repeats form a radiating color pattern in this swatch. Keep in mind, though, that as the number of stitches increases, the colors will change faster and produce narrower and narrower stripes. If there's a lot of contrast between the colors, this can result in distracting color stripes instead of gentle gradations.

Yarn: Crystal Palace Mini Mochi.

Swatch 2. The light colored, semisolid yarn used in this swatch works well. The subtle color variation doesn't distract from the lacework.

Yarn: Araucania Itata Solid.

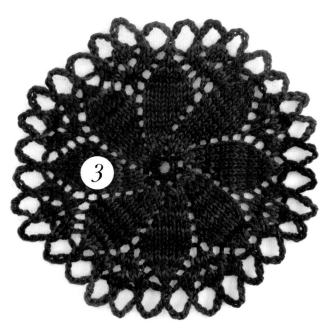

Swatch 3. For this swatch, I used a darker tone-on-tone yarn, which has some bright highlights and some mohair content. Again, the subtle color variation doesn't distract from the lace pattern. The mohair adds a soft halo.

Yarn: Mountain Colors Bear Foot.

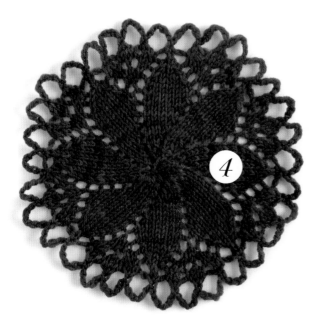

Swatch 4. The multicolor yarn in this swatch has short repeats, but because the colors are close in value, it enhances rather than distracts from the lace pattern.

Yarn: Fortissima Socka.

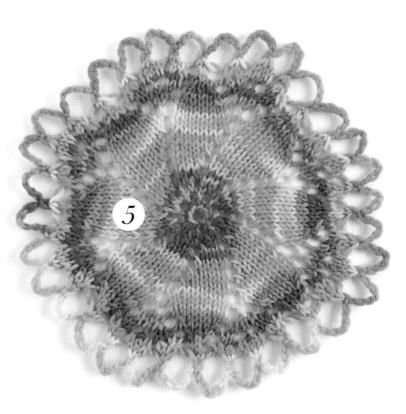

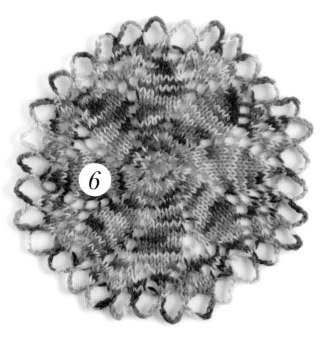

Swatch 5. The yarn in this swatch is very bright with medium-length color repeats. It stripes well in the center of the circle, but turns into short "spots" of color around the larger circumference of the bind-off edge. Therefore, I think this yarn would be best used for projects with small diameters.

Yarn: Regia Color 4-Ply Sock.

Swatch 6. I chose a yarn with multiple shades of gray for this sample. Because there's a wide range of value from very pale gray to dark charcoal, the variations distract from the lace pattern.

Yarn: Mystery sock yarn of unknown lineage.

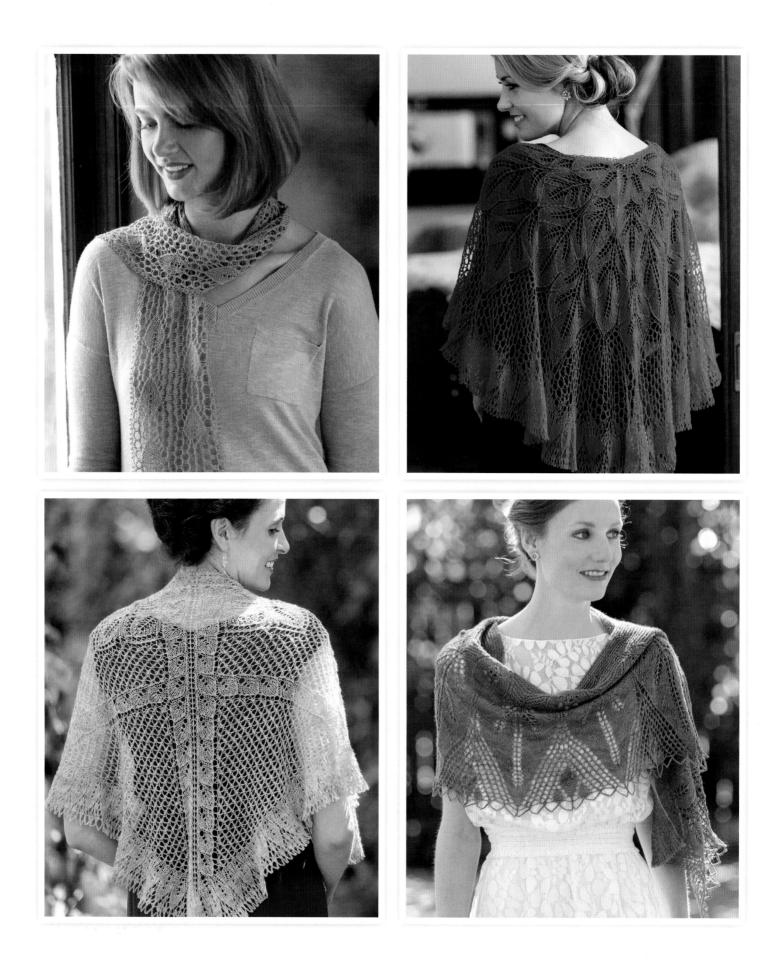

CHAPTER 4:
The Projects

The projects that follow will give you insight into my design process. The first group of projects consists of simple designs that can be completed with a single skein of yarn. The first two projects demonstrate how a vintage doily pattern can be translated into a contemporary hat. These are followed by a simple beret and scarf.

The remaining projects are divided into small shawls, triangles and squares, and larger projects that progress in size and time commitment. You can work the projects in any order that you choose, but if you progress in the order they're presented, you'll be able to build on the skills you acquire as you go!

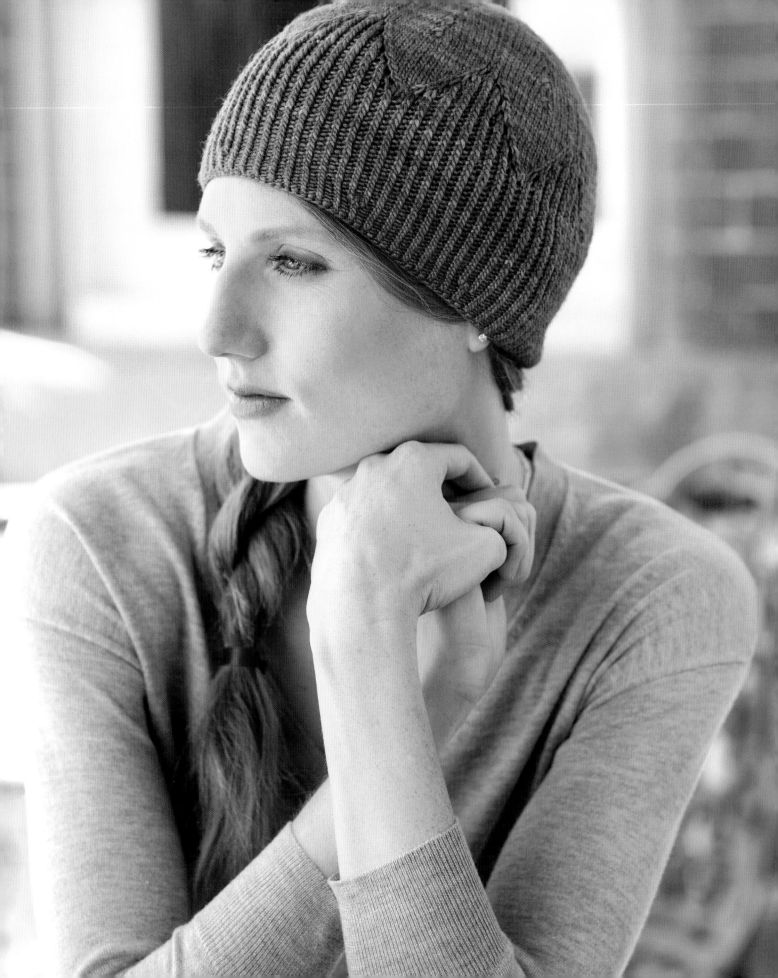

Clematis Doily and Beanie

This project is a great introduction to lace knitting. To begin, knit this very simple eight-wedge doily to learn the techniques. Each wedge is one petal of a simple flower. After Row 36, the flower petals taper as increases are worked in a simple fill pattern that expands the doily circumference. Try the delicate beanie next, in which the increases are followed by a twisted-rib pattern that forms a cylinder or tube on the circle to cover the ears. The doily is finished with a basic crochet bind-off; the beanie is finished with an elastic bind-off.

FINISHED SIZE

Doily: About 10½" (26.5 cm) in diameter.

Beanie: About 18" (475.5 cm) in circumference; will stretch comfortably to 20" (51 cm).

YARN

Doily: Laceweight (#0 Lace).

Shown here: Optima 10 (100% cotton; 306 yd [280 m]/50 g): #OPO29 Periwinkle, 1 ball (this is enough for at least two doilies).

Beanie: Fingering weight (#1 Super Fine).

Shown here: Malabrigo Silky Merino (50% baby merino, 50% silk; 150 yd [137 m]/50 g): #426 Plum Blossom, 1 skein.

NEEDLES

Doily: U.S. size 1 (2.25 mm): set of 5 double-pointed (dpn) and 16" (40 cm) circular (cir).

Beanie: U.S. size 3 (3.25 mm): set of 5 double-pointed (dpn) and sizes 3, 2, and 1 (3.25, 2.75, and 2.25 mm): 16" (40 cm) circular (cir) each.

Adjust needle size if necessary to obtain the correct gauge.

NOTIONS

Stitch marker (m): size 6 (1.8 mm) steel crochet hook for doily; tapestry needle; 7" (18 cm) bowl and coffee can for blocking beanie.

GAUGE

Doily: 18 sts and 24 rnds = 2" (5 cm) according to Clematis Doily Chart, worked in rnds, after blocking.

Beanie: 16 sts and 20 rnds = 2" (5 cm) on medium- size needles according to Rnds 53–60 of Clematis Beanie Chart, worked in rnds, after blocking.

Doily

With dpn, use the long-tail method (see page 19) to CO 8 sts. Divide sts evenly on 4 dpn so that there are 2 sts on each needle. Place marker and join for working in rnds, being careful not to twist sts. Slip marker every rnd.

Knit 1 rnd.

Work Rnds 1–59 of Clematis Doily Chart, changing to cir needle when there are too many sts to fit comfortably on dpn and ending 1 st before end of last rnd—240 sts.

With RS facing, use the gathered crochet method (see page 17) to BO as foll: *gather 3, chain 8; rep from *. Secure the final chain st to the first group of gathered sts with a sl st. Cut yarn, leaving a 9" (23 cm) tail. Pull tail through rem loop to secure.

FINISHING

Weave in loose ends but do not trim the tails.

Soak in cool water at least 30 minutes. Roll in a towel to remove extra water. Lay on a flat padded surface and place a pin in each crochet loop, stretching firmly to finished dimensions. Allow to air-dry completely before removing pins.

Trim tails on woven-in ends.

TIP: When working in the round, you can use the cast-on tail instead of a stitch marker to indicate the beginning of rounds. Just weave the tail between your needles as you pass the start-of-round! This is especially handy when you work on double-pointed needles.

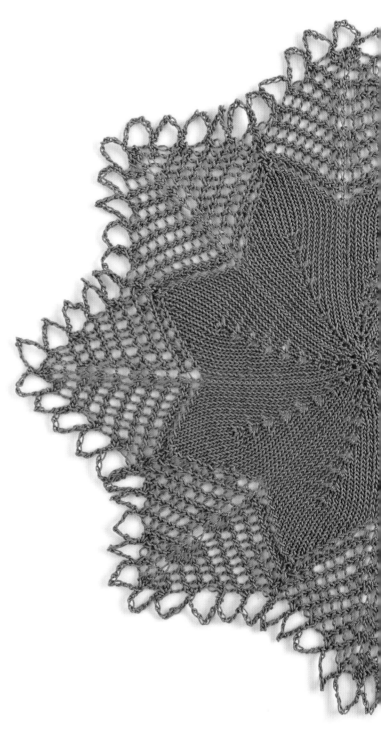

Clematis Doily Chart

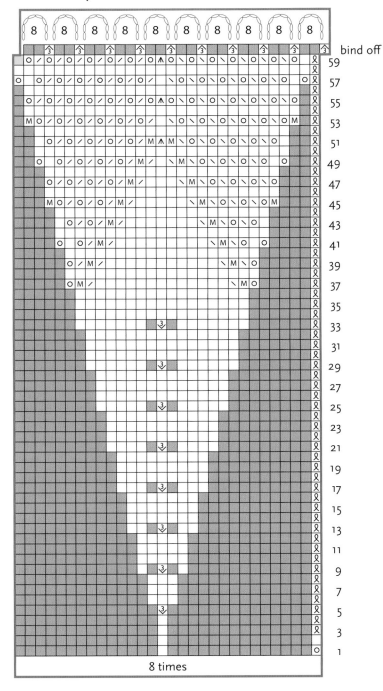

□	knit
○	yo
Ƨ	k1tbl
M	M1 without twist (see page 24)
⤓	[k1, p1, k1] into same stitch
╲	ssk
╱	k2tog
⋀	s2kp
(gray box)	knit on all reps except the last rep; end rnd 1 st before end of rnd, replace beg of rnd marker before this st, shifting beg of rnd 1 st to the right
③	gather 3
0	crochet chain
(gray box)	no stitch
□	stitch pattern repeat

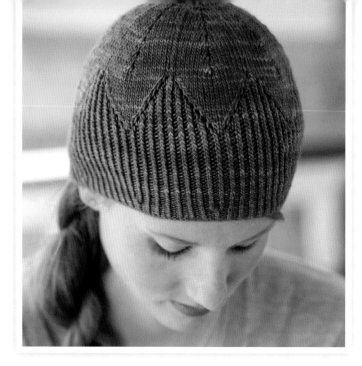

Beanie

With dpns, use the long-tail method (see page 19) to CO 8 sts. Divide sts evenly on 4 dpn so that there are 2 sts on each needle. Place marker and join for working in rnds, being careful not to twist sts. Slip marker every rnd.

Knit 1 rnd.

Work Rnds 1–60 of Clematis Beanie Chart, changing to largest cir needle when there are too many sts to fit comfortably on dpns—144 sts.

Change to medium cir needle and work Rnds 53–60 once more.

Change to smallest cir needle and work Rnds 53–60 once more.

Work Rnds 61–66 of chart—128 sts rem.

BO as foll: *k2tog through back loops (tbl), bring yarn to front of work, return 1 st to left needle tip, p2tog, bring yarn to back of work, return 1 st to left needle tip; rep from *, ending k2togtbl, bring yarn to front of work, return 1 st to left needle tip, p2tog.

Cut yarn, leaving a 9" (23 cm) tail. Bring tail through rem st and pull tight to secure.

FINISHING

Weave in loose ends but do not trim tails.

Soak in cool water at least 30 minutes. Roll in a towel to remove extra water. Place over 7" (18 cm) diameter bowl. Place the bowl upside down on a cylinder (a coffee can works well) so that the ribbing hangs freely. Smooth flower design over the top of the bowl with your fingers. Allow to air-dry completely before removing from bowl.

Trim tails on woven-in ends.

Converting a Doily to a Beanie

To convert the doily pattern to a beanie, you need to decide how large a circle to make before working the straight cylinder. The average woman's head circumference is between 21" and 23" (53.5 and 58.5 cm). This means you'll want to work increases until you reach that circumference (for a fitted beanie), or until a radius of 3.3" to 3.7" (8.4 to 9.4 cm) is achieved, then work straight for the sides. You can make the circle a little larger for a slouchy style. Because wool is so elastic there's a lot of flexibility.

To determine the radius, you need to know a little geometry. The radius is equal to the circumference divided by two times the number pi (pi = 3.14).

Radius = circumference ÷ (2 × pi)

For example. Let's say that the head circumference is 23" (58.5 cm).

Radius = 23" (58.5 cm) ÷ (2 × 3.14)

= 23" (58.5 cm) ÷ 6.28

= 3.66" (8.4 cm)

If you know the number of rounds per inch (2.5 cm) of your knitting, you can determine how many rows to increase your circle for the desired radius, which corresponds to the desired 23" (58.5 cm) circumference.

Row gauge (rows/rounds per inch) × desired radius (inches) = number of rows to work while increasing

For example, let's say you're getting 9 rounds to the inch (2.5 cm).

9 rounds/inch × 3.66" (9.4 cm) = 32.94 rounds

You'll therefore want to work about 33 rows with regular increases before working straight for the sides.

Once you begin working the straight cylinder, you'll need to consider your stitch gauge in the stitch pattern you've selected. You can change needle size (either up or down) to increase or decrease the circumference. You can also add decreases if needed, depending on your gauge and how snug you want the fit. Your final circumference should be just a little smaller than your head circumference so it fits well and stays put. Both the Clematis and Peaseblossom (see page 42) projects will help you learn the process.

Clematis Beanie Chart

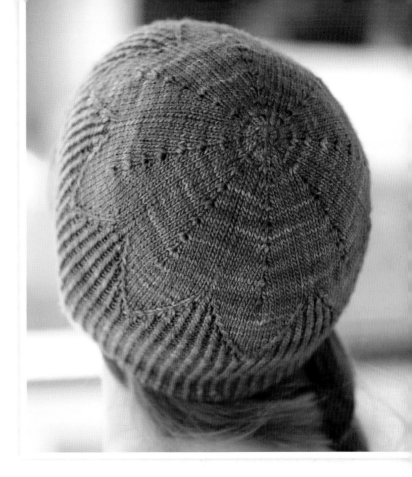

Row numbers shown on the right side of the chart (top to bottom): 65, 63, 61, 59, 57, 55, 53, 51, 49, 47, 45, 43, 41, 39, 37, 35, 33, 31, 29, 27, 25, 23, 21, 19, 17, 15, 13, 11, 9, 7, 5, 3, 1

once with each needle size

8 times

Legend

- ☐ knit
- • purl
- ℔ k1tbl
- Ⓜ M1 without twist (see page 24)
- ⬇ [k1, p1, k1] into same stitch
- \ ssk
- / k2tog
- ⋀ s2kp
- ▨ no stitch
- ☐ stitch pattern repeat
- ☐ row pattern repeat; work Rows 53–60 once with each needle size

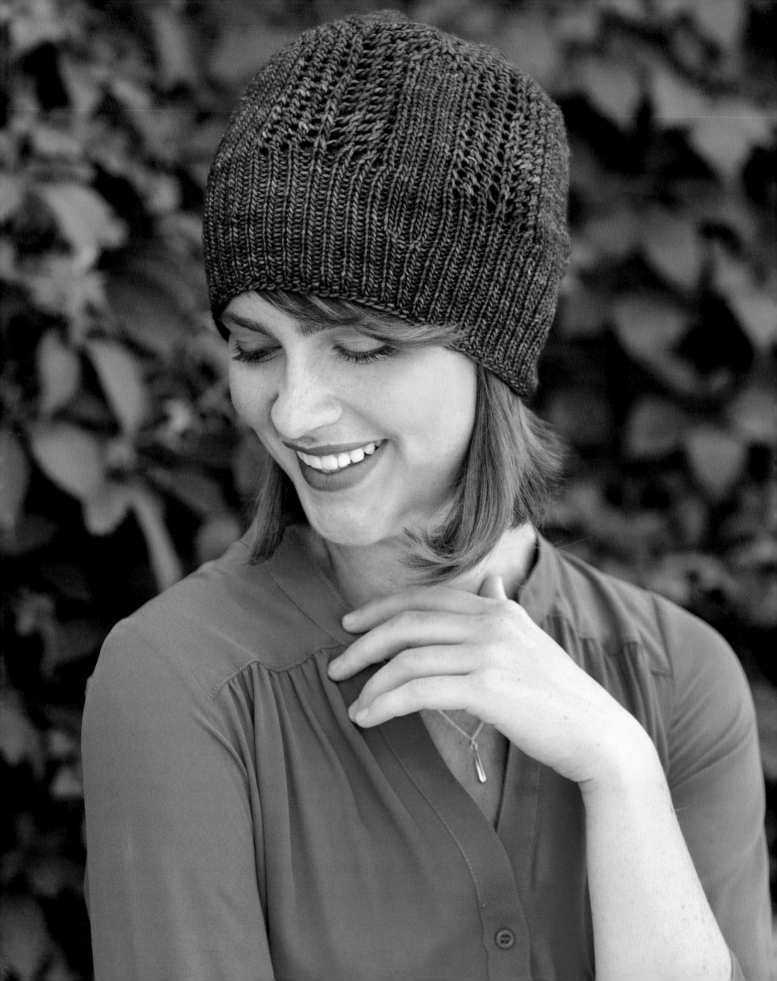

Peaseblossom Doily and Beanie

A very simple six-wedge doily is nice on its own, but it also makes a very nice beanie! Because all of the increases are worked in the first few rows, the shape is somewhat lumpy when it comes off the needles. But it just takes a little blocking to straighten things out! Knit the doily first to learn the pattern or skip ahead to the beanie.

FINISHED SIZE

Doily: About 8" (20.5 cm) in diameter.

Beanie: About 18" (45.5 cm) in circumference; will stretch comfortably to 22" to 24" (56 to 61 cm).

YARN

Doily: Laceweight (#0 Lace).

Shown here: Aunt Lydia Fashion Crochet #3 (100% cotton; 150 yd [137 m]/ball; no weight given): #625 Sage, 1 ball (this is enough for at least two doilies).

Beanie: DK weight (#3 Light).

Shown here: Madelinetosh Tosh Merino DK (100% merino; 225 yd [206 m]/100 g): Forestry, 1 skein.

NEEDLES

Doily: U.S. size 1 (2.25 mm): set of 4 double-pointed (dpn).

Beanie: U.S. size 4 (3.5 mm): set of 4 double-pointed (dpn) and 16" (40 cm) circular (cir).

Adjust needle size if necessary to obtain the correct gauge.

NOTIONS

Stitch marker (m); size 4 (2 mm) steel crochet hook for doily; tapestry needle; 7" (18 cm) bowl and coffee can for blocking beanie.

GAUGE

Doily: 16 sts and 17 rnds = 2" (5 cm) according to Peaseblossom Doily Chart, worked in rnds, after blocking.

Beanie: 12 sts and 18 rnds = 2" (5 cm) according to Rnd 59 of Peaseblossom Beanie Chart, worked in rnds, after blocking.

Doily

With dpn, use the long-tail method (see page 19) to CO 6 sts. Divide sts evenly on 3 double-pointed needles so that there are 2 sts on each needle. Place marker and join for working in rnds, being careful not to twist sts. Slip marker every rnd.

Knit 1 rnd.

Work Rnds 1–28 of Peaseblossom Doily Chart—120 sts.

With RS facing, use the gathered crochet method (see page 17) to BO as foll: *[gather 3, chain 6] 2 times, gather 3, chain 8, gather 5, chain 8, [gather 3, chain 6] 2 times; rep from *. Secure the final chain to the first group of gathered sts with a sl st.

Cut yarn, leaving a 9" (23 cm) tail. Pull tail through rem loop to secure.

FINISHING

Weave in loose ends but do not trim the tails.

Soak in cool water at least 30 minutes. Roll in a towel to remove extra water. Lay on a flat padded surface and place a pin in each crochet loop, stretching firmly to finished dimensions.

Allow to air-dry completely before removing pins.

Trim tails on woven-in ends.

Using Starch

Some yarns need a little starch to maintain a nice block. It's hard to tell how crisp your piece will look until you've blocked it and allowed it to dry. If it feels limper than you'd like, reblock it and apply a little spray starch to the damp, pinned-out doily. If you decide it's too stiff, simply wash the doily to remove the starch and reblock it.

Peaseblossom Doily Chart

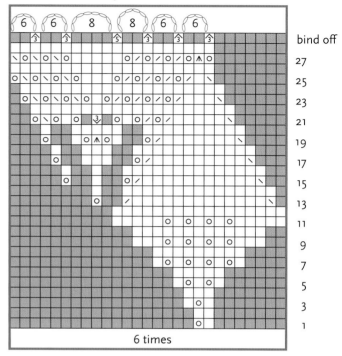

6 times

☐ knit

⊙ yo

☑ ssk

☑ k2tog

☑ s2kp

☑ [k1, p1, k1] in same stitch

③ gather 3

⑤ gather 5

0 crochet chain

▨ no stitch

☐ stitch pattern repeat

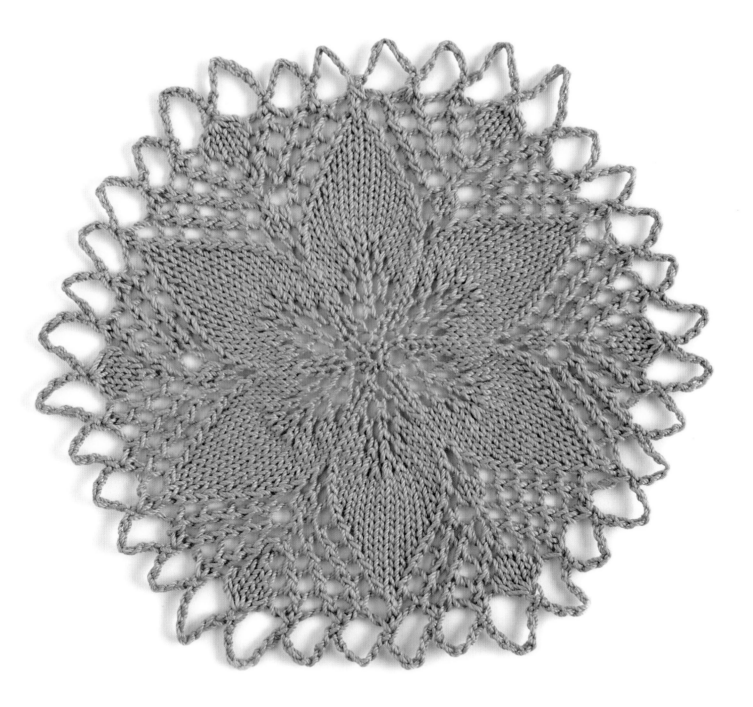

Beanie

With dpn, use the long-tail method (see page 19) to CO 6 sts. Divide sts evenly on 3 dpn so that there are 2 sts on each needle. Place marker and join for working in rnds, being careful not to twist sts. Slip marker every rnd.

Knit 1 rnd.

Work Rnds 1–36 of Peaseblossom Beanie Chart—120 sts.

Rep Rnds 29–36 two more times.

Work Rnds 37–59 once—108 sts.

Rep Rnd 59 as many times as you choose, or as your yarn allows (Rnd 59 was worked 3 extra times for the beanie shown).

BO as foll: *p2tog, bring yarn to back of work, return 1 st just worked to left needle tip, k2tog through the back loops (tbl), bring yarn to front of work, return 1 st just worked to left needle tip; rep from *, ending k2togtbl.

Cut yarn, leaving a 9" (23 cm) tail. Bring tail through rem st and pull tight to secure.

FINISHING

Weave in loose ends but do not trim the tails.

Soak in cool water at least 30 minutes. Roll in a towel to remove extra water. Place beanie over an inverted 7" (18 cm) bowl, then place the bowl on a coffee can, allowing the ribbing to hang free. Smooth the flower design over the top of the bowl, gently blocking with your fingers.

Allow to air-dry completely before removing pins.

Trim tails on woven-in ends.

☐	knit
☐	purl
☐	yo
☐	ssk
☐	k2tog
☐	s2kp
☐	[k1, p1, k1] in same stitch
☐	no stitch
☐	row pattern repeat; work Rows 29–36 three times
☐	stitch pattern repeat

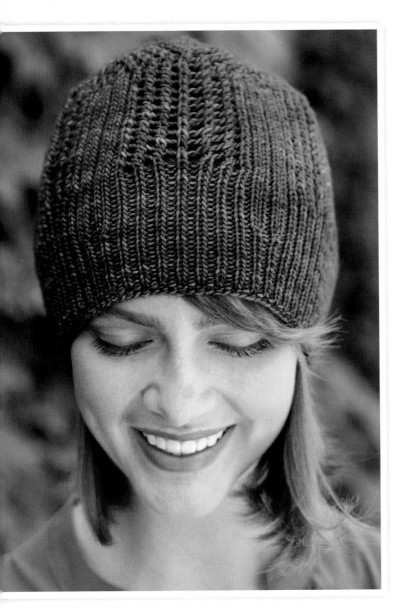

Peaseblossom Beanie Chart

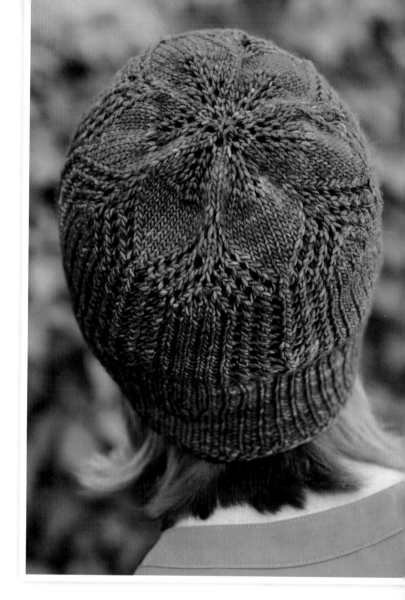

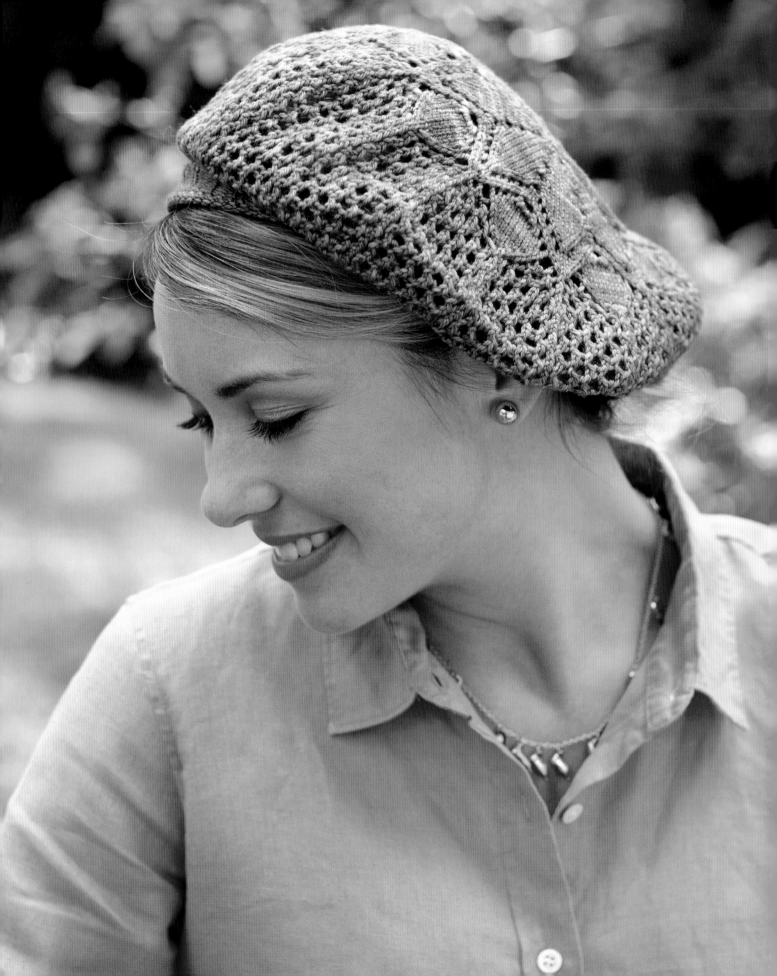

Giverny Beret

Featuring a relatively ornate center and a hex-mesh fill, this beret is a great introduction to working lace in rounds. Once you understand how a beret is constructed, you can follow the general instructions to use fingering- or sock-weight yarn to turn any other eight-wedge doily into a similar beret.

FINISHED SIZE

About 16" (40.5 cm) in circumference; will stretch comfortably to 19" (48.5 cm).

YARN

Fingering weight (#1 Extra Fine).

Shown here: Malabrigo Sock (100% superwash merino wool; 440 yd [402 m]/100 g): Indicita, 1 skein.

NEEDLES

Beret: U.S. size 2 (2.75 mm): set of 5 double-pointed (dpn) and 16" and 24" (40 and 60 cm) circular (cir).

Bind-off: U.S. size 4 (3.5 mm), or any needle that's one to two sizes larger than used for the beret.

Adjust needle size if necessary to obtain the correct gauge.

NOTIONS

Size 2 (2.25 mm) steel crochet hook for circular cast-on; stitch marker (m); tapestry needle; 11" (28 cm) dinner plate and coffee can for blocking.

GAUGE

12 sts and 20 rnds = 2" (5 cm) according to Rnds 61–72 of Giverny chart, worked in rnds on smaller needles, after blocking.

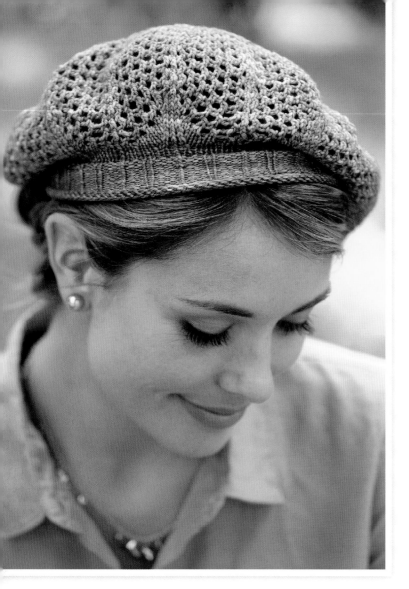

FINISHING

Weave in loose ends but do not trim the tails.

Soak in cool water at least 30 minutes (washing and rinsing if necessary). Roll in a towel to remove excess water. Place beret over an 11" (28 cm) dinner plate, gently stretching the top "flower" so that it lies flat and using your fingers to block into shape. Place the plate over the coffee can, allowing the headband to hang below the plate.

Allow to air-dry completely before moving.

Trim tails on woven-in ends.

☐	knit
⊡	purl
⊙	yo
▪	remove beg of rnd m, knit first st of rnd, then replace m, shifting beg of rnd 1 st to the left
◥	ssk
◿	k2tog
⋀	s2kp
⊻	[k1, p1, k1] in same stitch
⊠	k1tbl
⋋	sssk
⋌	k3tog
▪	no stitch
☐	stitch pattern repeat
☐	row pattern repeat; work Rnds 41–44 four times

Beret

With crochet hook, use Emily Ocker's Circular method (see page 18) to CO 8 sts. Divide sts evenly on 4 dpn so that there are 2 sts on each needle. Place marker and join for working in rnds, being careful not to twist sts. Slip marker every rnd.

Knit 1 rnd.

Work Rnds 1–44 of Giverny Chart, changing to progressively longer cir needle as necessary—200 sts.

Rep Rnds 41–44 three more times, then work Rnds 45–77, changing to shorter cir needle as necessary—96 sts rem.

With larger needle, BO as foll: K2, *return 2 sts just worked to left needle tip, k2tog, k1; rep from *, ending k2tog.

Cut yarn, leaving a 9" (23 cm) tail. Bring tail through rem st and pull tight to secure.

Giverny Chart

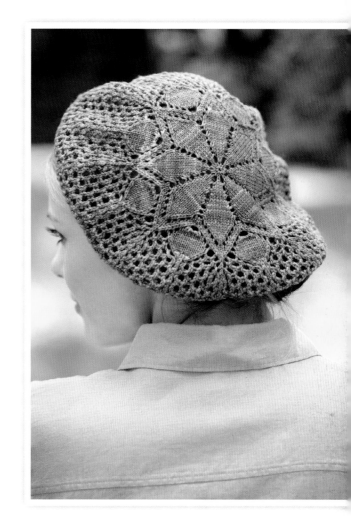

Chart row numbers (right side, odd numbers): 77, 75, 73, 71, 69, 67, 65, 63, 61, 59, 57, 55, 53, 51, 49, 47, 45, 43, 41, 39, 37, 35, 33, 31, 29, 27, 25, 23, 21, 19, 17, 15, 13, 11, 9, 7, 5, 3, 1

4 times

8 times

Blue Vinca Scarf

Two variations of this scarf show how you can take the same leaf motif and hex-mesh fill to space the motif in different ways. Version 1 has three columns of leaf patterns for overall symmetrical spacing; Version 2 has just two columns for a more asymmetrical look. The mesh fill between the leaf motifs, called hex-mesh, was a favorite of Herbert Niebling. For Version 1, the beads are applied with the help of a crochet hook; for Version 2, the beads are prestrung onto the yarn and slipped into place as needed. Knit both versions to learn both methods for adding beads.

FINISHED SIZE

VERSION 1: About 5½" (14 cm) wide and 53" (134.5 cm) long.

VERSION 2: About 5¾" (14.5 cm) wide and 42½" (108 cm) long.

YARN

Laceweight (#0 Lace).

Shown here:

VERSION 1: Land O Lace Kayla (100% 20/2 silk; 600 yd [549 m]/60 g): Frazee, 1 skein.

VERSION 2: Classic Elite Silky Alpaca Lace (70% alpaca, 30% silk; 440 yd [402 m]/50 g): #2477 Forget-Me-Not, 1 skein.

NEEDLES

VERSION 1: U.S. size 0 (2 mm): short straight needles.

VERSION 2: U.S. size 1 (2.25 mm): short straight needles.

Note: Short straight single-point needles work well for scarves.

Adjust needle size if necessary to obtain the correct gauge.

NOTIONS

VERSION 1: 7 g Miyuki 2.5mm triangle seed beads (shown in silver-lined pale blue TR2430); size 14 (.75 mm) steel crochet hook for applying beads.

VERSION 2: 10 g 8/0 Japanese seed beads (shown in Matsuno #642 silver-lined sapphire AB); dental floss threader to string beads.

BOTH VERSIONS: Tapestry needle; straight blocking wires; T-pins.

GAUGE

VERSION 1: 41 sts = 5½" (14 cm) and 24 rows = 3" (7.5 cm) according to Blue Vinca Version 1 Chart, after blocking.

VERSION 2: 34 sts = 6" (15 cm) and 24 rows = 2¾" (7 cm) according to Blue Vinca Version 2 Chart, after blocking.

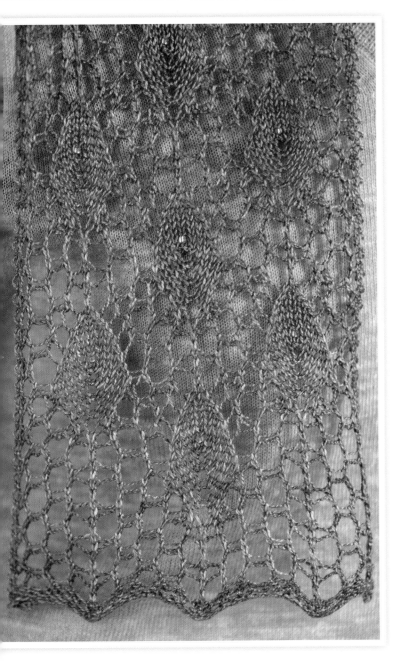

VERSION 1:

Applied Beads

Holding two needles together, use the long-tail method (see page 19) to CO 41 sts. Remove extra needle.

Work Rows 1–44 of Blue Vinca Chart Version I, adding beads with the smaller crochet hook (see page 16) as specified.

Rep Rows 21–44 fifteen more times or until scarf measures 2¼" (5.5 cm) less than desired total length.

Work Rows 45–64 once.

With RS facing, BO as foll: k2, *return 2 sts just worked to left needle tip, k2tog, k1; rep from *, omitting the final k1 on the last rep.

Cut yarn, leaving a 9" (23 cm) tail. Bring tail through rem st and pull tight to secure.

FINISHING

Weave in loose ends but do not trim tails.

Soak in cool water for at least 30 minutes. Roll in a towel to remove excess water.

Weave blocking wires through both long edges (you'll need two wires or one 60" [152.5 cm] wire for each of the two long edges), inserting the wires through the garter bumps along the selvedges. Place on a flat padded surface and pin the wires, making sure the edges are straight and parallel, until piece measures about 5½" (14 cm) wide and is as long as it can be gently stretched. Pin scallops along both short edges.

Allow to air-dry completely before removing wires and pins.

Trim tails on woven-in ends.

Blue Vinca Chart (Version 1)

16 times

63
61
59
57
55
53
51
49
47
45
43
41
39
37
35
33
31
29
27
25
23
21
19
17
15
13
11
9
7
5
3
1

☐ knit on RS, purl on WS

· purl on RS, knit on WS

⊙ yo

⁄ k2tog

⟍ ssk

⋀ s2kp

⅊ [k1, p1, k1] in same stitch

▨ no stitch

⅄ k1tbl on RS, p1tbl on WS

■ place bead

☐ pattern repeat

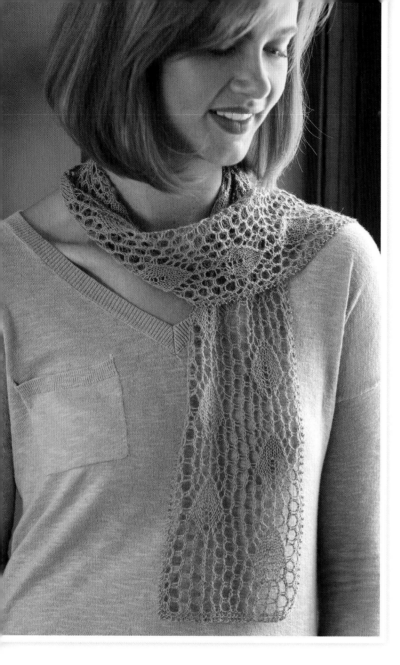

Using a dental-floss threader, prestring 680 beads onto yarn (see page 16).

Holding two needles together, use the long-tail method (see page 19) to CO 34 sts. Remove extra needle.

Placing a bead (see Stitch Guide) at the start of every row, work Rows 1–44 of Blue Vinca Chart Version 2.

Rep Rows 21–44 eleven more times or until scarf measures 4" (10 cm) less than desired total length.

Work Rows 45–76 once.

With RS facing, BO as foll: k2, *return 2 sts just worked to left needle tip, k2tog, k1; rep from *, omitting the final k1 on the last rep.

Cut yarn, leaving a 9" (23 cm) tail. Bring tail through rem st and pull tight to secure.

FINISHING

Weave in loose ends but do not trim tails.

Soak in cool water for at least 30 minutes. Roll in a towel to remove excess water.

Weave blocking wires through all four edges (you'll need two wires or one 60" [152.5 cm] wire for each of the two long edges), inserting the wires through the garter bumps along the selvedges. Place on a flat padded surface and pin the wires, making sure the edges are straight and parallel, until piece measures about 5¾" (14.5 cm) wide and as long as it can be gently stretched.

Allow to air-dry completely before removing wires and pins.

Trim tails on woven-in ends.

VERSION 2:

Prestrung Beads

Stitch Guide

Place a bead: Slide a bead up against the knitting needle, then knit the next stitch, being careful to keep the bead from sliding into the stitch.

Blue Vinca Chart (Version 2)

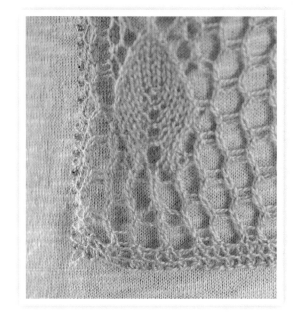

	
☐	knit on RS, purl on WS
•	purl on RS, knit on WS
○	yo
╱	k2tog
╲	ssk
⋀	s2kp
⅋	[k1, p1, k1] in same stitch
▨	no stitch
ያ	k1tbl on RS, p1tbl on WS
☐	pattern repeat

12 times

Row numbers (right side, top to bottom): 75, 73, 71, 69, 67, 65, 63, 61, 59, 57, 55, 53, 51, 49, 47, 45, 43, 41, 39, 37, 35, 33, 31, 29, 27, 25, 23, 21, 19, 17, 15, 13, 11, 9, 7, 5, 3, 1

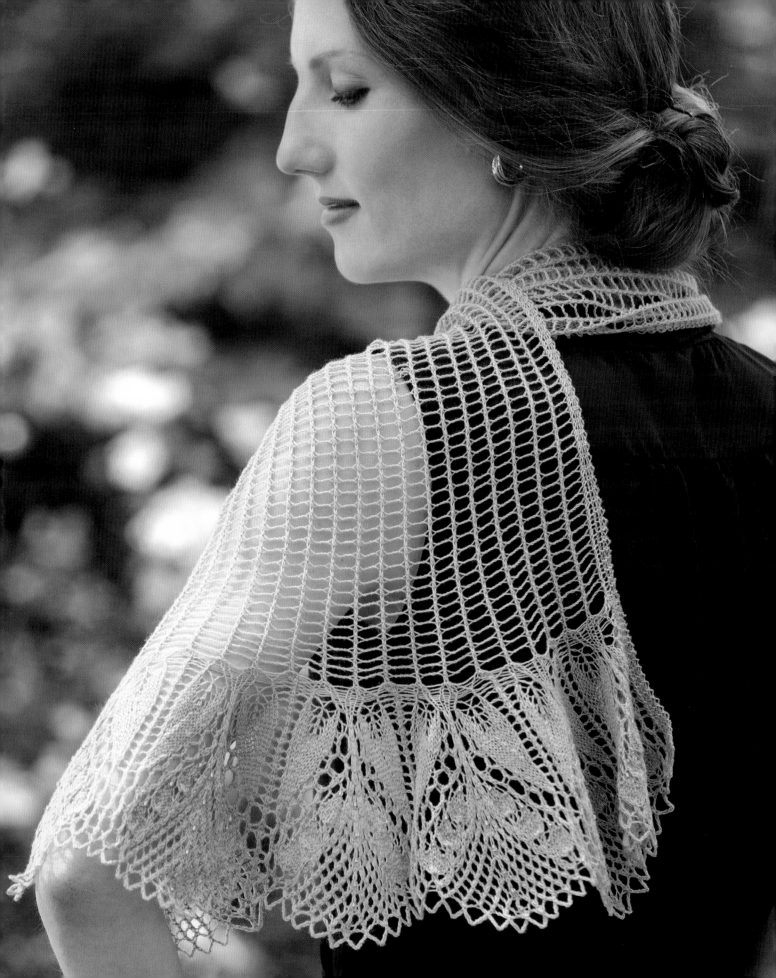

Cherry Blossom Stole

This stole was inspired by a handkerchief edging I saw in the German publication *Erikas Handarbeiten #80*. No year or attribution to the designer was included. The body of the stole is a simple mesh pattern, of which I've used an assortment throughout this book. Several of the pieces use traditional hex-mesh, favored by Herbert Niebling. The Sunflower projects (page 94) use a mesh similar to one used by Marianne Kinzel. Others, including Diospyros Wrap (page 108) and Ghost Orchid (page 120), use a directional linear mesh. The very open and vertically linear mesh in this stole is one that I created myself, or "unvented," as Elizabeth Zimmermann would say.

FINISHED SIZE

About 12" (30.5 cm) wide at center and 72" (183 cm) long, blocked; about 10¾" (27.5 cm) wide at center and 72" (183 cm) long, after relaxing.

YARN

Laceweight (#0 Lace).

Shown here: Jade Sapphire Lacey Lamb (100% extrafine lambswool; 825 yd [754 m]/60 g): #211 Dusty Pink, 1 ball.

NEEDLES

U.S. size 2 (2.75 mm): 24" (60 cm) circular (cir).

Adjust needle size if necessary to obtain the correct gauge.

NOTIONS

About 10 g of 8/0 Japanese seed beads (shown in Toho color 377G Metallic Rose lined AB); size 14 (0.75 mm) steel crochet hook, or size to fit beads; a few yards (meters) of smooth waste yarn for provisional cast-on; size 00 (3.5 mm) steel crochet hook for bind-off; tapestry needle; two flexible blocking wires or one 60" [152.5 cm] wire; T-pins.

GAUGE

26 sts and 30 rows = 4" (10 cm) according to Cherry Blossom Chart B, relaxed after blocking.

Notes

Beads are applied with a crochet hook (see page 16).

A circular needle is used to accommodate the large number of sts on edgings. Do not join; work back and forth in rows.

Because the edgings are semicircular, the overall piece has an hourglass, not rectangular, shape.

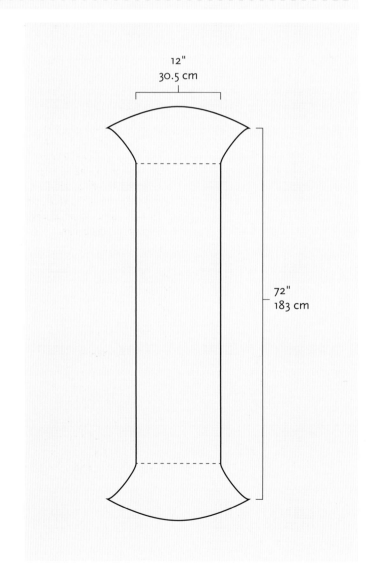

FIRST EDGING

Using a provisional method (see page 19), CO 70 sts.

Knit 1 row.

Next row: (WS) K3, p64, k3.

Adding beads with smaller crochet hook (see page 16) as specified, work Rows 1–42 of Cherry Blossom Chart A—273 sts.

Using the larger crochet hook, use the gathered crochet method (see page 17) to BO as foll: Gather 5, chain 6, gather 4, chain 6, [gather 3, chain 6] 9 times, gather 4, chain 6, *gather 3, chain 6, gather 4, chain 6, [gather 3, chain 6] 9 times, gather 4, chain 6; rep from * 5 more times, gather 5.

Cut yarn, leaving a 9" (23 cm) tail. Pull tail through rem loop to secure.

STOLE

With WS facing, carefully remove waste yarn from provisional CO and place 70 exposed sts onto needle.

Join yarn in preparation to work a RS row. Knit 2 rows, ending with a WS row—1 garter ridge.

Rep Rows 1 and 2 of Cherry Blossom Chart B until piece measures about 62" (157.5 cm) from provisional CO, ending after WS Row 2 of patt. Knit 2 rows—1 garter ridge.

SECOND EDGING

Work Rows 1–42 of Cherry Blossom Chart A, placing beads same as for first edging.

Use the crochet method to BO same as first edging.

FINISHING

Weave in loose ends but do not trim tails.

Soak in cool water for at least 30 minutes. Roll in a towel to remove excess water.

Weave flexible blocking wires through garter bumps along the straight selvedges. Place on a flat padded surface and pin the wires as well as each loop along the short ends to block into semicircular shapes (alternatively, thread very flexible blocking wires through each loop and pin the wires).

Block to 12" (30.5 cm) wide along straight section and 72" (183 cm) long, maintaining the overall hourglass shape.

Allow to air-dry thoroughly before removing wires and pins.

Trim tails on woven-in ends.

Cherry Blossom Chart A

Cherry Blossom Chart B

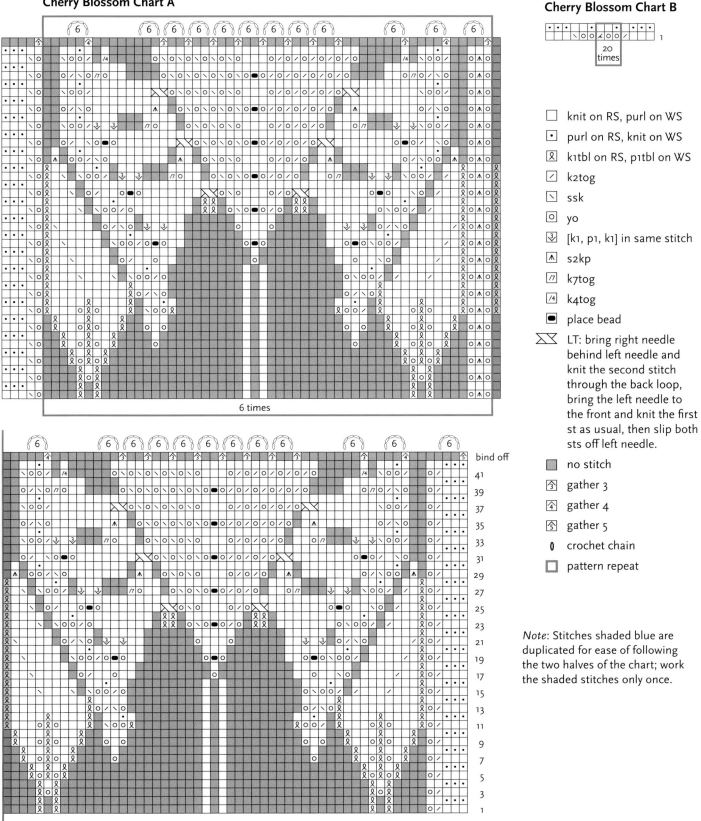

knit on RS, purl on WS

• purl on RS, knit on WS

⅋ k1tbl on RS, p1tbl on WS

／ k2tog

＼ ssk

○ yo

↨ [k1, p1, k1] in same stitch

⋀ s2kp

⫽ k7tog

⁄4 k4tog

▣ place bead

LT: bring right needle behind left needle and knit the second stitch through the back loop, bring the left needle to the front and knit the first st as usual, then slip both sts off left needle.

no stitch

⅌ gather 3

⅍ gather 4

⅏ gather 5

0 crochet chain

pattern repeat

Note: Stitches shaded blue are duplicated for ease of following the two halves of the chart; work the shaded stitches only once.

6 times

bind off

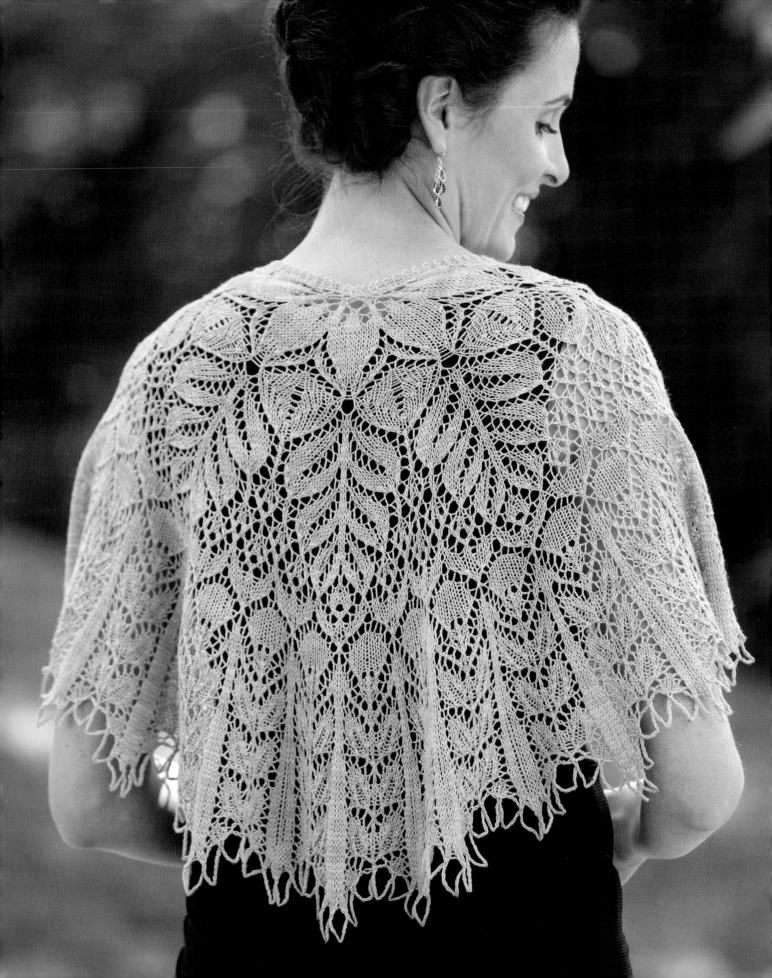

Kodama

This shawl was inspired by a doily in *Kunststricken 1698*, from *Verlag für die Frau.* The pamphlet is out of print. No publication year or attribution to designer is included. This shawl includes a nice deep version of a classic border pattern. A diminutive version of the same style of border is used on the Ghost Orchid shawl on page 120.

FINISHED SIZE

About 42" (106.5 cm) wide at the top and 21" (53.5 cm) long at center back, blocked; about 38" (96.5 cm) wide at top and 19" (48.5 cm) long at center back, after relaxing.

YARN

Laceweight (#0 Lace).

Shown here: Sweet Georgia, Merino Silk Lace (50% merino, 50% silk; 765 yd [699 m]/100 g): Pistachio, 1 skein.

NEEDLES

U.S. size 3 (3.25 mm): 32" (80 cm) circular (cir).

Adjust needle size if necessary to obtain the correct gauge.

NOTIONS

15 g of 8/0 Japanese seed beads (shown in Toho #996 gold-lined peridot AB); size 14 (0.75 mm) steel crochet hook, or size to fit beads; 12" (30.5 cm) of smooth waste yarn for provisional cast-on; two stitch markers (m; optional); size 4 (2 mm) steel crochet hook for bind-off; tapestry needle; flexible blocking wires; T-pins.

GAUGE

10 sts and 13 rows = 2" (5 cm) according to Kodama B and C charts, relaxed after blocking.

Notes

Beads are applied with a crochet hook (see page 16).

A circular needle is used to accommodate the large number of sts. Do not join; work back and forth in rows.

Optional markers may be placed after first 3 sts and before last 3 sts to denote garter-stitch edges.

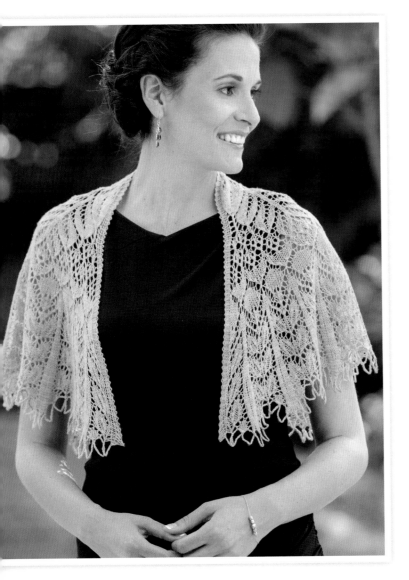

SHAWLETTE

Using a provisional method (see page 19), CO 4 sts.

Knit 10 rows—5 garter ridges. Do not turn after working the last row.

Turn work 90 degrees and, working into each garter bump, pick up and purl (see page 25) 5 sts along one selvedge (1 st in each garter ridge)—9 sts total.

Carefully remove waste yarn from provisional CO and knit the 4 exposed sts—13 sts total.

Adding beads with smaller crochet hook (see page 16) as specified, work Rows 1–62 of Kodama Chart A—218 sts.

Work Rows 63–74 of Kodama Chart B—239 sts.

Work Rows 75–120 of Kodama Chart C—512 sts.

With the larger crochet hook, use the gathered crochet method (see page 17) to BO as foll: gather 4, chain 8, gather 2, chain 10, gather 5, chain 10, [gather 3, chain 10] 2 times, *[gather 3, chain 10, gather 5, chain 10] 2 times, [gather 3, chain 10] 2 times; rep from * to last 14 sts, gather 3, chain 10, gather 5, chain 10, gather 2, chain 8, gather 4.

Cut yarn, leaving a 9" (23 cm) tail. Pull tail through rem loop to secure.

FINISHING

Weave in loose ends but do not trim tails.

Soak in cool water for at least 30 minutes. Roll in a towel to remove excess water.

Weave flexible blocking wires into garter bumps along "straight" top edge. Place on flat padded surface and block to finished measurements by pinning out each crochet loop along scalloped bottom edge.

Allow to air-dry thoroughly before removing wires and pins.

Trim tails on woven-in ends.

Kodama Chart A

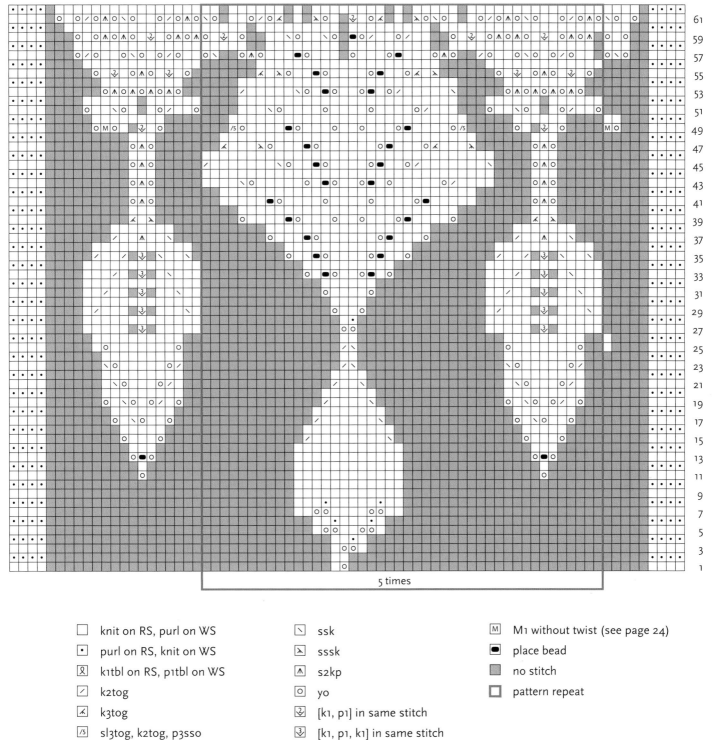

5 times

	knit on RS, purl on WS		ssk	M	M1 without twist (see page 24)
•	purl on RS, knit on WS		sssk	◨	place bead
ꓮ	k1tbl on RS, p1tbl on WS		s2kp		no stitch
	k2tog	○	yo		pattern repeat
	k3tog		[k1, p1] in same stitch		
/5	sl3tog, k2tog, p3sso		[k1, p1, k1] in same stitch		

Kodama Chart B

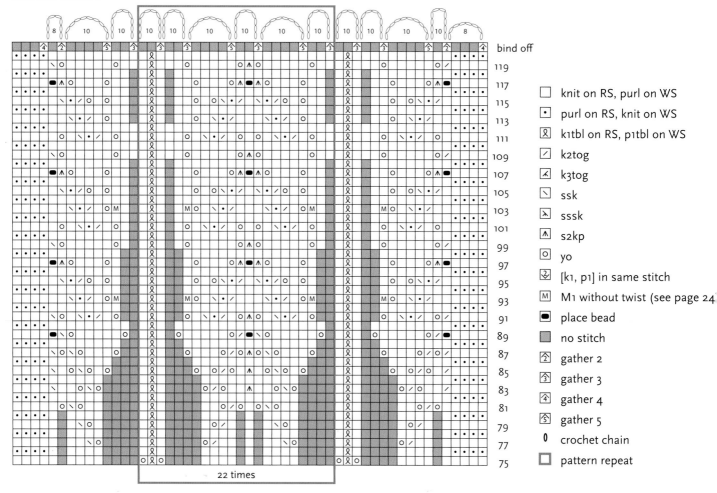

Kodama Chart C

☐	knit on RS, purl on WS
•	purl on RS, knit on WS
ᛘ	k1tbl on RS, p1tbl on WS
╱	k2tog
⦦	k3tog
╲	ssk
⋋	sssk
⋀	s2kp
○	yo
⦧	[k1, p1] in same stitch
M	M1 without twist (see page 24)
⬤	place bead
▨	no stitch
⤒2	gather 2
⤒3	gather 3
⤒4	gather 4
⤒5	gather 5
0	crochet chain
☐	pattern repeat

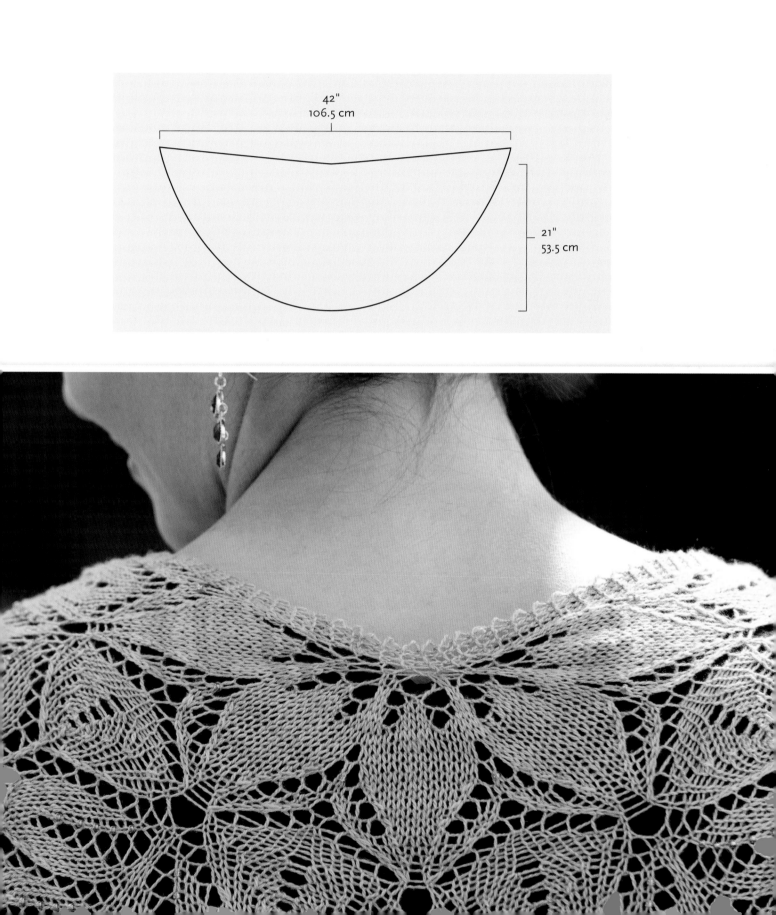

42"
106.5 cm

21"
53.5 cm

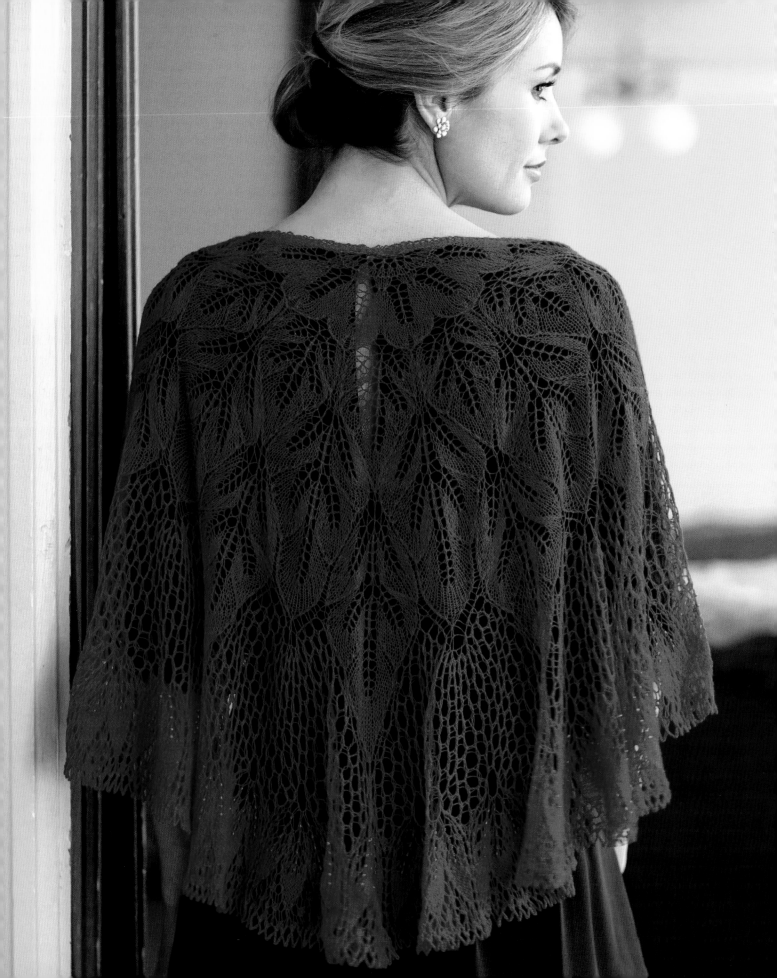

Coeur d'Amour

This shawl was inspired by several different large doilies that date from the 1930s. The yarn used here provides a classic lace-knitting experience. The yarn feels soft and fine as you knit, but once the piece is removed from the needles, it looks like a shapeless mess that the cat dragged in. There's a lot of magic in blocking!

FINISHED SIZE

About 48" (122 cm) wide at top and 24" (61 cm) long at center back, blocked; about 43½" (110.5 cm) wide at top and 21¾" (55 cm) long at center back, after relaxing.

YARN

Laceweight (#0 Lace).

Shown here: Jade Sapphire Lacey Lamb (100% extrafine lambswool; 825 yd [754 m]/60 g): #225 Blueblood Red, 1 ball.

NEEDLES

U. S. size 2 (2.75 mm): 40" (100 cm) circular (cir).

Adjust needle size if necessary to obtain the correct gauge.

NOTIONS

20 g of 8/0 Japanese seed beads (shown in #011A silver-lined red); size 14 (0.75 mm) steel crochet hook (or size to fit beads); 12" (30.5 cm) smooth waste yarn for provisional cast-on; two stitch markers (m; optional); size 4 (2 mm) steel crochet hook for bind-off; tapestry needle; flexible blocking wires; T-pins.

GAUGE

12 sts and 14 rows = 2" (5 cm) according to Coeur d'Amour Chart C, relaxed after blocking.

Notes

Beads are applied with a crochet hook (see page 16).

A circular needle is used to accommodate large number of sts. Do not join; work back and forth in rows.

Optional markers may be placed after first 3 sts and before last 3 sts to denote garter-stitch edges.

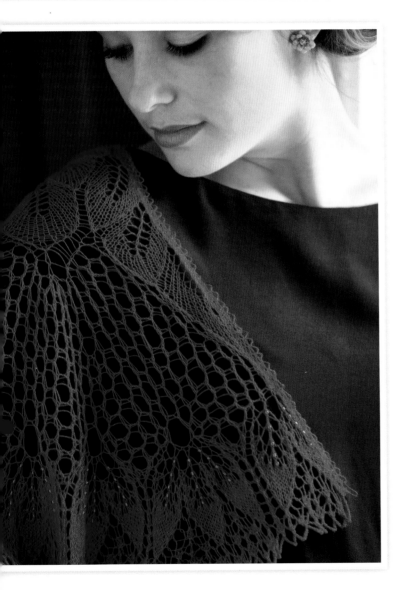

SHAWL

Using a provisional method (see page 19), CO 3 sts.

Knit 12 rows—6 garter ridges. Do not turn after working the last row.

Turn work 90 degrees and pick up and knit (see page 25) 6 sts along one selvedge (1 st in each garter ridge)—9 sts total.

Carefully remove waste yarn from provisional CO and knit the 3 exposed sts—12 sts total.

Work Rows 1–28 of Coeur d'Amour Chart A—90 sts.

Work Rows 29–48 of Coeur d'Amour Chart B—151 sts.

Work Rows 49–68 of Coeur d'Amour Chart C—199 sts.

Work Rows 69–94 of Coeur d'Amour Chart D—247 sts.

Work Rows 95–128 of Coeur d'Amour Chart E—457 sts.

Adding beads with smaller crochet hook (see page 16) as specified, work Rows 1–24 of Coeur d'Amour Border chart—1,267 sts.

With the larger crochet hook, use the gathered crochet method (see page 17) to BO as foll: gather 5, chain 8, *gather 3, chain 8; rep from * to last 5 sts, gather 5.

Cut yarn, leaving a 9" (23 cm) tail. Pull tail through rem loop to secure.

FINISHING

Weave in loose ends but do not trim tails.

Soak in cool water for at least 30 minutes. Roll in a towel to remove excess water.

Weave flexible blocking wires into garter bumps along "straight" top edge and into each crochet chain loop along the BO edge (the loops will be a little crowded on the wires).

Place on flat padded surface and pin out wires to the finished measurements, forming a semicircle.

Allow it to air-dry thoroughly before removing wires and pins— border will form a gentle ruffle of leaves.

Trim tails on woven-in ends.

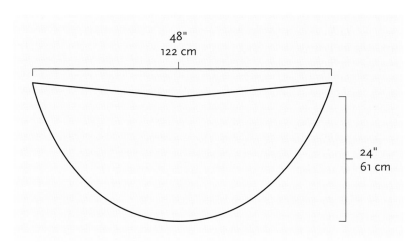

48"
122 cm

24"
61 cm

Coeur d'Amour Chart A

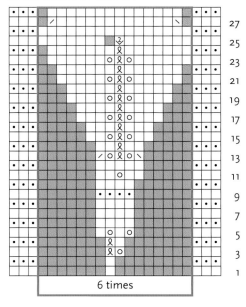

6 times

	Symbol	Description
	□	knit on RS, purl on WS
	•	purl on RS, knit on WS
	ℛ	k1tbl on RS, p1tbl on WS
	╱	k2tog
	╲	ssk
	⋀	s2kp
	○	yo
	⤓	[k1, p1] in same stitch
	▨	no stitch
	□	pattern repeat

Coeur d'Amour Chart B

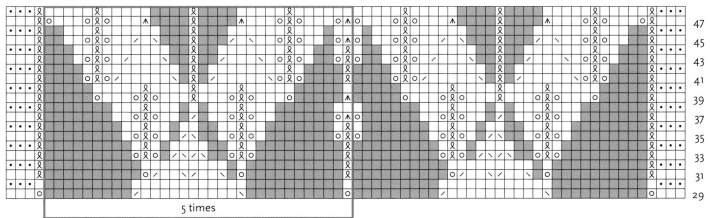

5 times

Coeur d'Amour Chart C

5 times

Note: Stitches shaded blue are duplicated for ease of following the two halves of the chart; work the shaded stitches only once.

Coeur d'Amour Chart D

5 times

Note: Stitches shaded green are duplicated for ease of following the two halves of the chart; work the shaded stitches only once.

knit on RS, purl on WS

· purl on RS, knit on WS

knit1tbl on RS, p1tbl on WS

k2tog

k3tog

ssk

sssk

s2kp

yo

no stitch

pattern repeat

67
65
63
61
59
57
55
53
51
49

93
91
89
87
85
83
81
79
77
75
73
71
69

Coeur d'Amour Chart E

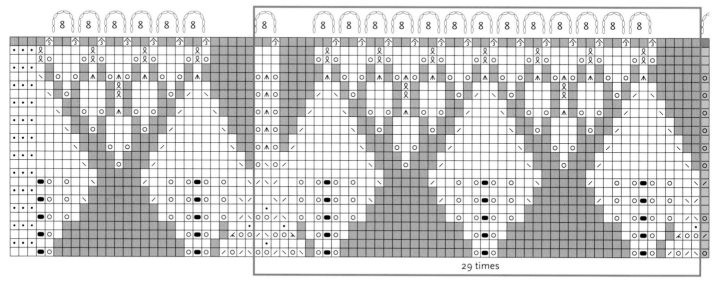

5 times

Note: Stitches shaded blue are duplicated for ease of following the two halves of the chart; work the shaded stitches only once.

Coeur d'Amour Border Chart

29 times

Note: Stitches shaded green are duplicated for ease of following the two halves of the chart; work the shaded stitches only once.

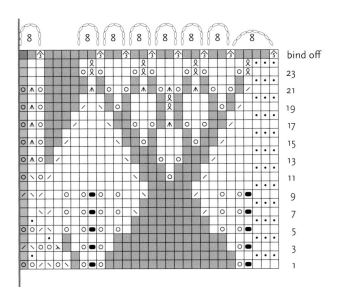

	knit on RS, purl on WS
•	purl on RS, knit on WS
ℛ	k1tbl on RS, p1tbl on WS
∕	k2tog
⫽	k3tog
＼	ssk
⑊	sssk
⋀	s2kp
○	yo
⤓	[k1, p1] in same stitch
⤒	[k1, p1, k1] into strand between stitches
⬛	place bead
③	gather 3
⑤	gather 5
0	crochet chain
▨	no stitch
□	pattern repeat

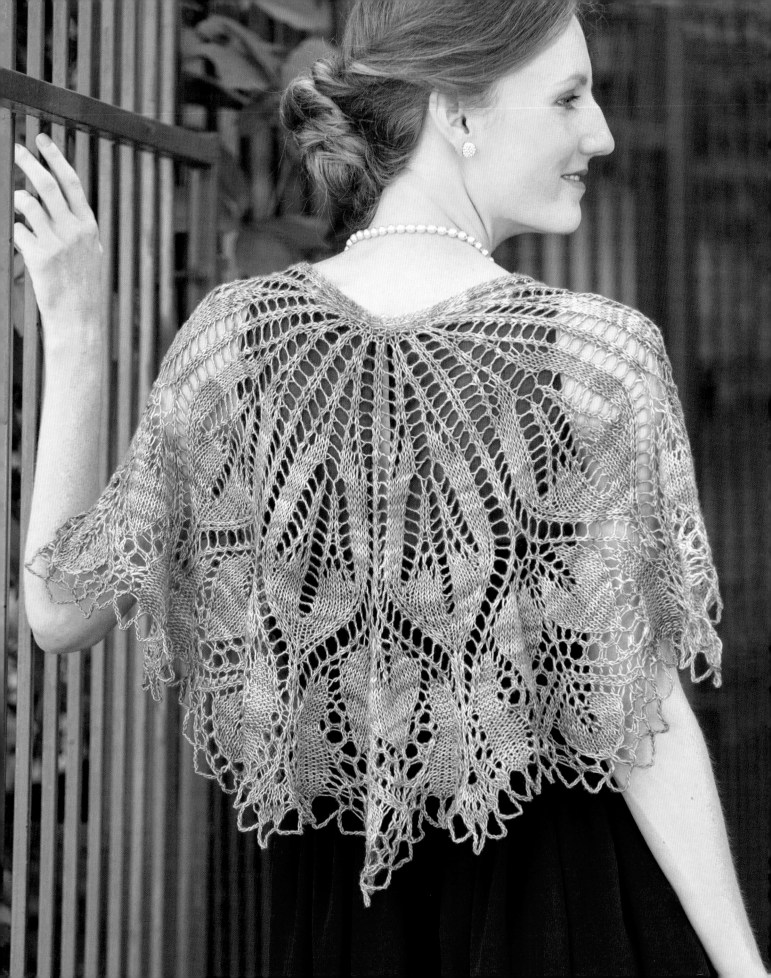

Blue Dahlia

This small shawl was inspired by a doily in the 1959 Elsa Publication *Kunststrickheft* from Verlag Johannes Schwabe. No attribution to the designer was included in this out-of-print magazine. Knitted in a heavier yarn than most projects in this book, this shawlette has strong lines. Because the lace is so bold, you can get away with a yarn that has a little color variation. The beads are applied with a crochet hook as the stitches are knitted.

FINISHED SIZE

About 42" (106.5 cm) wide at top and 21" (53.5 cm) long at center back, blocked; about 36" (91.5 cm) wide at top and 18" (45.5 cm) long at center back, after relaxing.

YARN

Fingering weight (#1 Super Fine).

Shown here: Madelinetosh Tosh Merino Light (100% merino; 420 yd [367 m]/100 g): Well Water, 1 skein.

NEEDLES

U.S. size 7 (4.5 mm): 32" (80 cm) circular (cir).

Adjust needle size if necessary to obtain the correct gauge.

NOTIONS

About 15 g of 6/0 seed beads (shown in Czech E-beads, aqua copper-lined); size 14 (0.75 mm) crochet hook, or size to fit beads; 12" (30.5 cm) smooth waste yarn for provisional cast-on; two stitch markers (m; optional); size 1 (2.75 mm) steel crochet hook for bind-off; tapestry needle; flexible blocking wires; T-pins.

GAUGE

9 sts and 11 rows = 2" (5 cm) according to Blue Dahlia Chart A, relaxed after blocking.

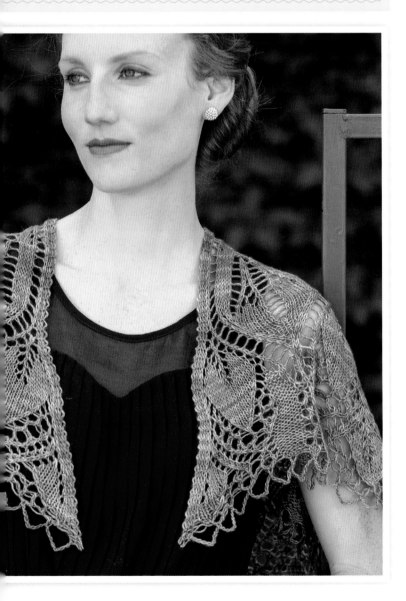

SHAWLETTE

Using a provisional method (see page 19), CO 3 sts.

Knit 12 rows—6 garter ridges. Do not turn after working last row.

Turn work 90 degrees and, working into each garter bump, pick and purl (see page 25) 6 sts along one selvedge (1 st in each garter ridge)—9 sts total.

Carefully remove waste yarn from provisional CO and knit the 3 exposed sts—12 sts total.

Adding beads with smaller crochet hook (see page 16) as specified, work Rows 1–42 of Blue Dahlia Chart A—198 sts.

Work Rows 43–60 of Blue Dahlia Chart B—307 sts.

Work Rows 61–72 of Blue Dahlia Chart C—319 sts.

Work Rows 73–82 of Blue Dahlia Chart D—367 sts.

With the larger crochet hook, use the gathered crochet method (see page 17) to BO as foll: gather 3, chain 8, [gather 4, chain 8] 3 times, gather 4, chain 10, gather 5, chain 10, *[gather 3, chain 8] 5 times, gather 4, chain 10, gather 5, chain 10, [gather 4, chain 8] 3 times, gather 3, chain 8, [gather 4, chain 8] 3 times, gather 4, chain 10, gather 5, chain 10; rep from * 4 more times, [gather 3, chain 8] 5 times, gather 4, chain 10, gather 5, chain 10, [gather 4, chain 8] 4 times, gather 3.

Cut yarn, leaving a 9" (23 cm) tail. Pull tail through rem loop to secure.

FINISHING

Weave in loose ends but do not trim tails.

Soak in cool water for at least 30 minutes. Roll in a towel to remove excess water.

Weave flexible blocking wires into garter bumps along "straight" top edge. Place on a flat padded surface and block to finished measurements by pinning out each crochet loop as foll: pin out each of the leaf sections, then pin out the small starbursts, then pin out the two longer loops between the leaves and starbursts.

Allow to air-dry thoroughly before removing wires and pins.

Trim tails on woven-in ends.

Blue Dahlia Chart A

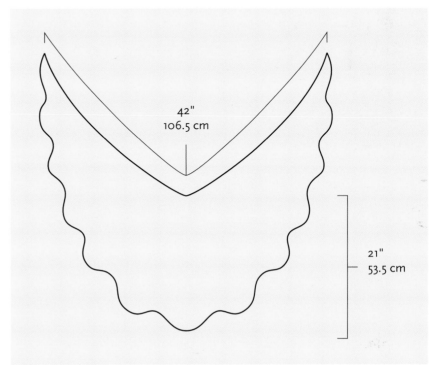

- ☐ knit on RS, purl on WS
- ⊡ purl on RS, knit on WS
- ⤓ [k1, p1] in same stitch
- ℞ k1tbl on RS, p1tbl on WS
- ○ yo
- ⟍ ssk
- ⟋ k2tog
- Ⓜ M1 without twist (see page 24)
- ⬤ place bead, knitting tbl
- ▨ no stitch
- ☐ pattern repeat

5 times

42"
106.5 cm

21"
53.5 cm

Blue Dahlia Chart B

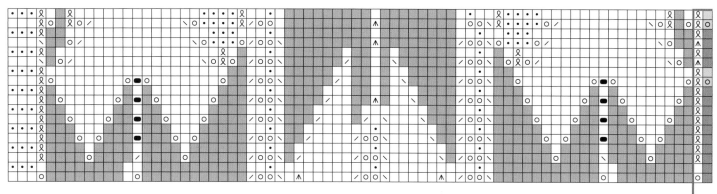

Note: Stitches shaded blue are duplicated for ease of following the two halves of the chart; work the shaded stitches only once.

Blue Dahlia Chart C

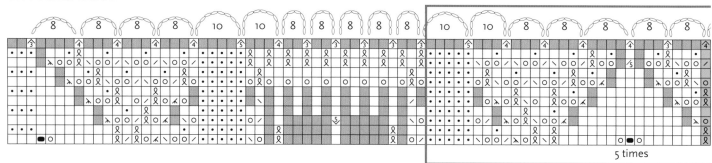

Blue Dahlia Chart D

Note: Stitches shaded green are duplicated for ease of following the two halves of the chart; work the shaded stitches only once.

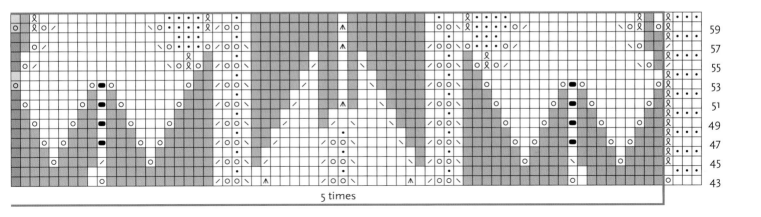

□	knit on RS, purl on WS	⟋ᴋ	k3tog
•	purl on RS, knit on WS	⬇5	[k1, p1, k1, p1, k1] in same stitch
⬇	[k1, p1] in same stitch	⟋5	k5tog
𝚵	k1tbl on RS, p1tbl on WS	⬆3	gather 3
o	yo	⬆4	gather 4
⟍	ssk	⬆5	gather 5
⟋	k2tog	0	crochet chain
◼	place bead		no stitch
⋏	s2kp	□	pattern repeat
⟍ᴋ	sssk		

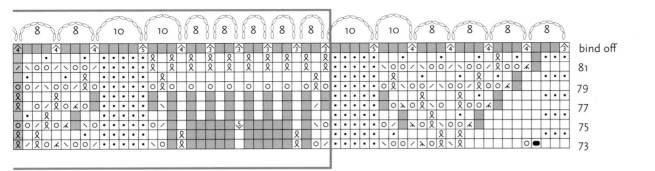

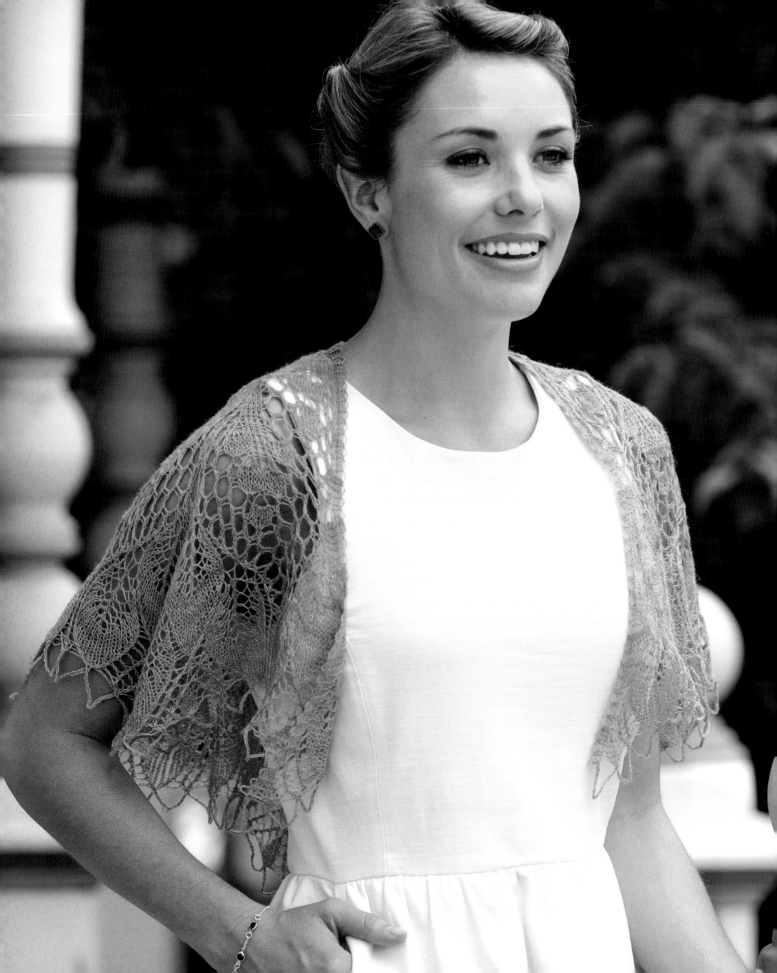

Nereid

This piece was inspired by a doily I saw in a Burda publication from the 1950s that's no longer in print. Including a fun texture and mesh fill, this shawl may be one of the more challenging pieces in this book. But it's also one of the most fun to knit! The small blossoms or fruit are created by increasing several stitches at once, then decreasing them a few rows later. The same technique is used in the Cherry Blossom Stole on page 58.

FINISHED SIZE

About 43" (109 cm) wide at top and 19" (48.5 cm) long at center back, blocked; about 38" (96.5 cm) wide at top and 16" (40.5 cm) long at center back, after relaxing.

YARN

Laceweight (#0 Lace).

Shown here: Manos del Uruguay Lace (70% alpaca, 25% silk, 5% cashmere; 439 yd [400 m]/50 g): Alvina Aqua, 1 skein.

NEEDLES

U.S. size 5 (3.75 mm): 32" (80 cm) circular (cir).

Adjust needle size if necessary to obtain the correct gauge.

NOTIONS

About 5 g of 1.5mm square beads (shown in Toho #264, teal-lined rainbow); size 14 (0.75 mm) steel crochet hook, or size to fit beads; 12" (30.5 cm) smooth waste yarn for provisional cast-on; two stitch markers (m; optional); size 4 (2 mm) steel crochet hook for bind-off; tapestry needle; flexible blocking wires; T-pins.

GAUGE

12 sts and 12 rows = 2" (5 cm) according to Nereid Chart D, relaxed after blocking.

Notes

Beads are applied with a crochet hook (see page 16).

A circular needle is used to accommodate large number of sts. Do not join; work back and forth in rows.

Optional markers may be placed after first 3 sts and before last 3 sts to denote garter-stitch edges.

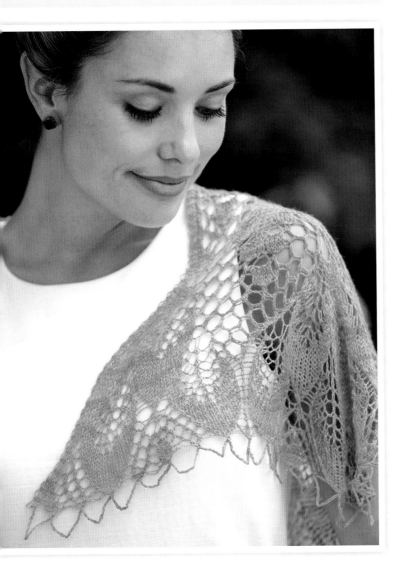

SHAWL

Using a provisional method (see page 19), CO 3 sts.

Knit 8 rows—4 garter ridges. Do not turn after working last row.

Turn work 90 degrees and, working into each garter ridge, pick up and knit (see page 25) 1 st, [yo, pick up and knit 1 st] 3 times—10 sts total.

Carefully remove waste yarn from provisional CO and knit the 3 exposed sts—13 sts total.

Work Rows 1–28 of Nereid Chart A—134 sts.

Adding beads with the smaller crochet hook (see page 16) as specified, Work Rows 29–52 of Nereid Chart B—275 sts.

Work Rows 53–64 of Nereid Chart C—415 sts.

Work Rows 65–90 of Nereid Chart D—403 sts.

With the larger crochet hook, use the gathered crochet method (see page 17) to BO as foll: gather 3, chain 12, gather 4, chain 12, gather 5, chain 12, gather 3, chain 12, gather 5, chain 12, gather 7, chain 12, gather 5, chain 12, gather 3, chain 12, *[gather 3, chain 12] 2 times, [gather 5, chain 12, gather 7, chain 12, gather 5, chain 12, gather 3, chain 12] 3 times; rep from * 5 more times, [gather 3, chain 12] 2 times, gather 5, chain 12, gather 7, chain 12, gather 5, chain 12, gather 3, chain 12, gather 5, chain 12, gather 4, chain 12, gather 3.

Cut yarn, leaving a 9" (23 cm) tail. Pull tail through rem loop to secure.

FINISHING

Weave in loose ends but do not trim tails.

Soak in cool water for at least 30 minutes. Roll in a towel to remove excess water.

Weave flexible blocking wires into garter bumps along "straight" top edge. Place on flat padded surface and, beginning with the center back and working toward each side, pin out each crochet BO loop to finished measurements as foll: pin out each of the leaf sections, forming rounded areas. Then pin out the two loops between the rounded leaf sections.

Allow to air-dry thoroughly before removing wires and pins.

Trim tails on woven-in ends.

Nereid Chart A

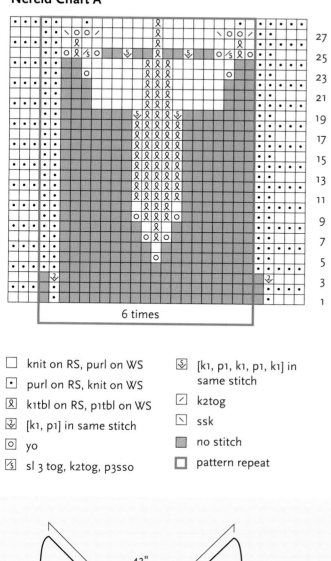

6 times

☐	knit on RS, purl on WS	
⦁	purl on RS, knit on WS	
℞	k1tbl on RS, p1tbl on WS	
⤓	[k1, p1] in same stitch	
○	yo	
⑤	sl 3 tog, k2tog, p3sso	
⤓	[k1, p1, k1, p1, k1] in same stitch	
╱	k2tog	
╲	ssk	
▧	no stitch	
☐	pattern repeat	

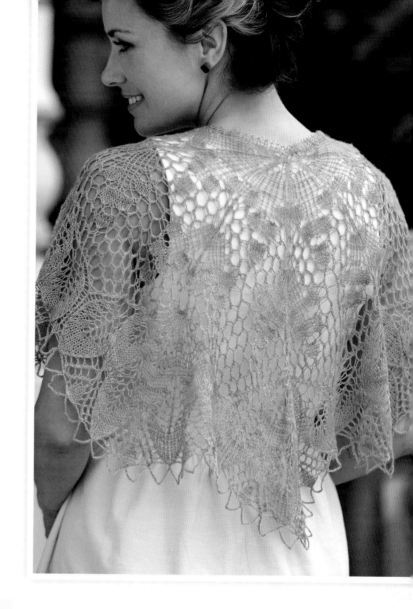

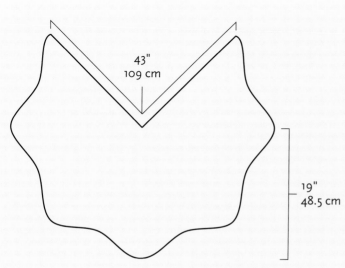

43"
109 cm

19"
48.5 cm

Nereid Chart B

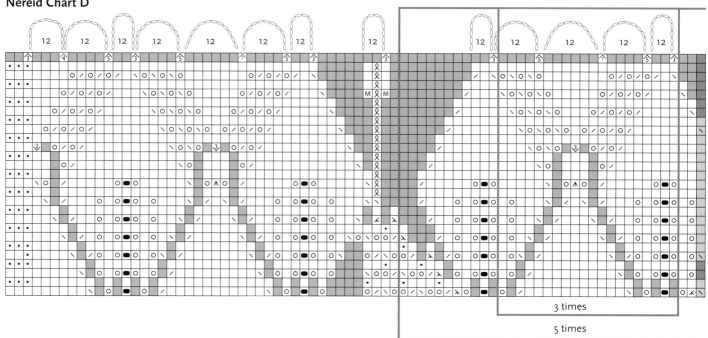

5 times

Note: Stitches shaded blue are duplicated for ease of following the two halves of the chart; work the shaded stitches only once.

Nereid Chart C

5 times

Note: Stitches shaded green are duplicated for ease of following the two halves of the chart; work the shaded stitches only once.

Nereid Chart D

3 times

5 times

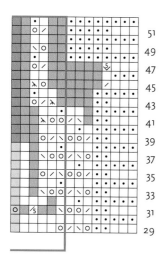

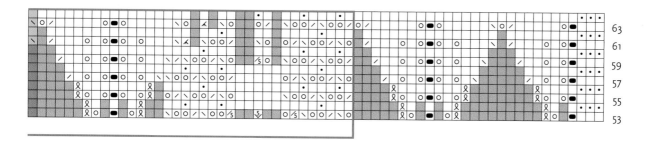

knit on RS, purl on WS

· purl on RS, knit on WS

k1tbl on RS, p1tbl on WS

[k1, p1] in same stitch

○ yo

sl 3 tog, k2tog, p3sso

[k1, p1, k1, p1, k1] in same stitch

╱ k2tog

╲ ssk

M M1 without twist (see page 24)

sssk

k3tog

[k1, p1, k1, p1, k1, p1, k1, p1, k1] in same stitch

■ place bead

s2kp

[k1, p1, k1] in same stitch

gather 3

gather 4

gather 5

gather 7

no stitch

0 crochet chain

large pattern repeat

small pattern repeat

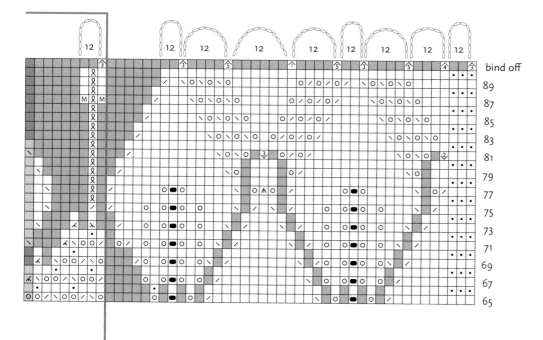

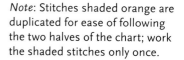

Note: Stitches shaded orange are duplicated for ease of following the two halves of the chart; work the shaded stitches only once.

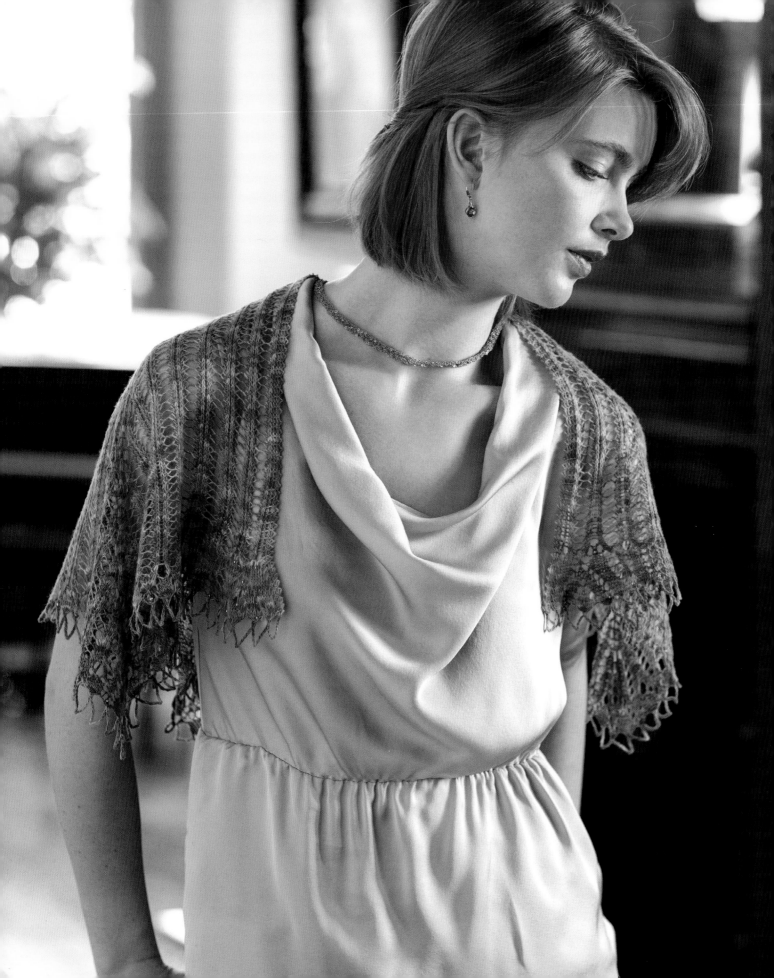

Willow

I took inspiration from a doily in Burda Publication #305 from 1974 for this shawlette. No attribution to the designer is included in this out-of-print magazine. Worked as a modified triangle, this shawlette is one of the simpler projects in this book. You can make a larger shawl by adding more row repeats, but be sure to purchase more yarn if you do. I've included instructions for using stitch markers to help you keep your place.

FINISHED SIZE

About 40" (101.5 cm) wide and 24" (61 cm) long at center back, after blocking; about 30" (76 cm) wide and 19" (48.5 cm) long at center back, after relaxing.

YARN

Laceweight (#0 Lace).

Shown here: Pagewood Farms U-Knitted Nations Artesana (100% merino; 545 yd [498 m]/50 g): Army Girl, 1 skein.

NEEDLES

U.S. size 3 (3.25 mm): 32" (80 cm) circular (cir).

Adjust needle size if necessary to obtain the correct gauge.

NOTIONS

About 8 g of 8/0 Japanese seed beads (shown in Toho gold-lined AB peridot); 12" (30.5 cm) of smooth waste yarn for provisional cast-on; two stitch markers (m; optional); size 14 (0.75 mm) steel crochet hook, or size to fit beads; size 4 (2 mm) steel crochet hook for bind-off; tapestry needle; flexible blocking wires; T-pins.

GAUGE

13 sts and 15 rows = 2" (5 cm) according to Willow Chart B, relaxed after blocking.

Notes

A circular needle is used to accommodate large number of sts. Do not join; work back and forth in rows.

Beads are applied with a crochet hook (see page 16).

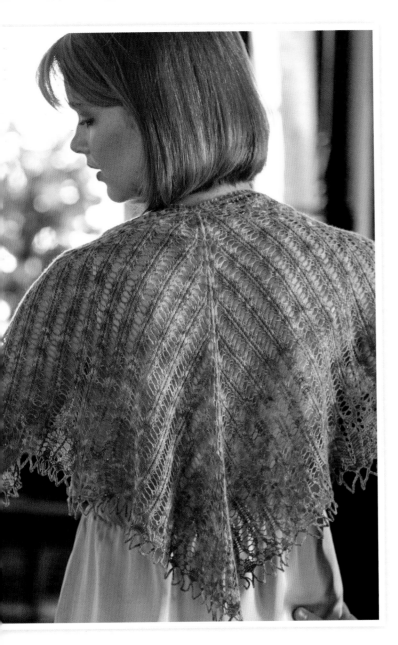

SHAWLETTE

Using a provisional method (see page 19), CO 3 sts.

Knit 6 rows—3 garter ridges. Do not turn after working the last row.

Turn work 90 degrees and, working into each garter bump, pick up and purl (see page 25) 3 sts along one selvedge—6 sts total.

Carefully remove waste yarn from provisional CO and knit the 3 exposed sts—9 sts total.

Beg with Row 1, work Willow Chart A as foll:

Row 1: (RS) K3, place marker (pm), *yo, k1, yo; rep from * 2 more times, pm, k3—15 sts.

Row 2: (WS) K3, slip marker (sl m), purl to next m, sl m, knit 3.

Cont in this manner, working Rows 3–20 of Willow Chart A—87 sts.

Work Rows 21–28 of Willow Chart B 9 times—411 sts.

Adding beads with the smaller crochet hook (see page 16) as specified, work Rows 29–46 of Willow Chart C—640 sts.

Adding beads with the smaller crochet hook as specified, work Rows 1 and 2 of Willow Border chart—783 sts.

Using the larger crochet hook, use the gathered crochet method (see page 17) to BO as foll: gather 3 sts, chain 10, [gather 6, chain 10] 2 times, gather 7, chain 10, *[gather 6, chain 10] 2 times, [gather 3, chain 10, gather 5, chain 10] 2 times, gather 3, chain 10, [gather 6, chain 10, gather 3, chain 10] 18 times, [gather 5, chain 10, gather 3, chain 10] 2 times, [gather 6, chain 10] 2 times, gather 7, chain 10, gather 6, chain 14, gather 12, chain 14, gather 6, chain 10, gather 7, chain 10; rep from * once, [gather 6, chain 10] 2 times, [gather 3, chain 10, gather 5, chain 10] 2 times, gather 3, chain 10, [gather 6, chain 10, gather 3, chain 10] 18 times, [gather 5, chain 10, gather 3, chain 10] 2 times, [gather 6, chain 10] 2 times, gather 7, chain 10, [gather 6, chain 10] 2 times, gather 3.

Cut yarn, leaving a 9" tail. Pull tail through rem loop to secure.

FINISHING

Weave in loose ends but do not trim tails.

Soak in cool water for at least 30 minutes. Roll in a towel to remove excess water.

Weave flexible blocking wires into top garter edges and crochet loops of side edges, omitting ten loops in the middle of each side and five loops at both ends for the corners. Place on a flat padded surface and pin the wires as well as the loops that were omitted from wires (this will form the corners) to finished dimensions.

Allow to air-dry thoroughly before removing wires and pins.

Trim tails on woven-in ends.

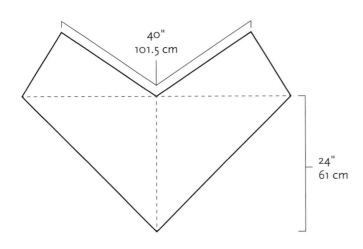

40"
101.5 cm

24"
61 cm

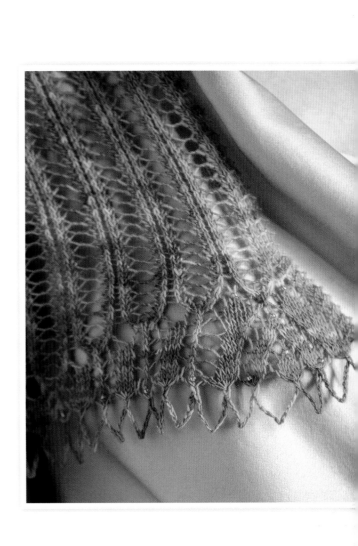

Willow Chart A

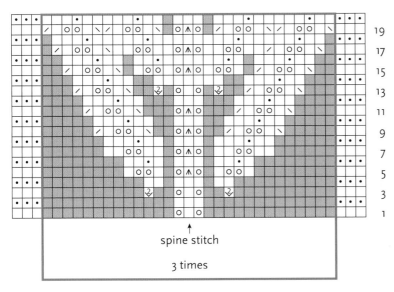

spine stitch

3 times

Willow Chart B

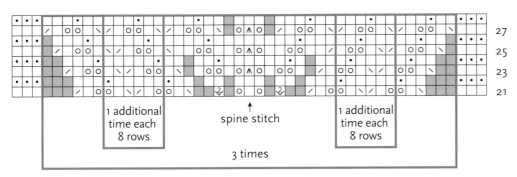

1 additional time each 8 rows

spine stitch

1 additional time each 8 rows

3 times

	knit on RS, purl on WS
•	purl on RS, knit on WS
⊙	yo
⊻	[k1, p1] in same stitch
⋀	s2kp
⟍	ssk
⟋	k2tog
□	large pattern repeat
□	small pattern repeat

Willow Chart C

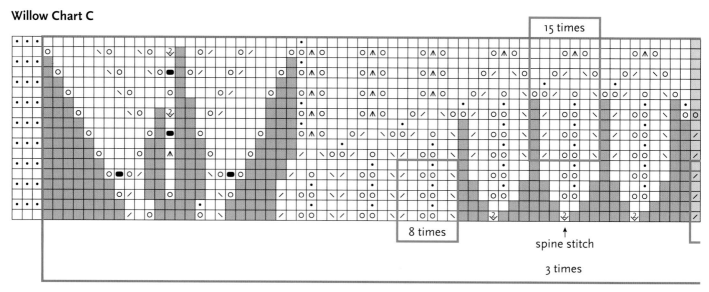

15 times

8 times

spine stitch

3 times

Note: Stitches shaded blue are duplicated for ease of following the two halves of the chart; work the shaded stitches only once.

Willow Border Chart

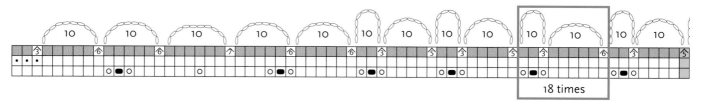

18 times

Note: Stitches shaded green are duplicated for ease of following the two halves of the chart; work the shaded stitches only once.

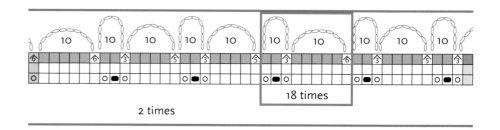

18 times

2 times

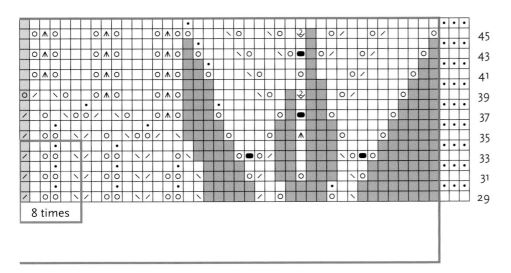

		knit on RS, purl on WS
	•	purl on RS, knit on WS
	o	yo
	⤸	[k1, p1] in same stitch
	⋏	s2kp
	⟍	ssk
	╱	k2tog
	■	place bead
		no stitch
	③	gather 3
	⑤	gather 5
	⑥	gather 6
	⑦	gather 7
	⑫	gather 12
	0	crochet chain
	☐	large pattern repeat
	☐	small pattern repeat

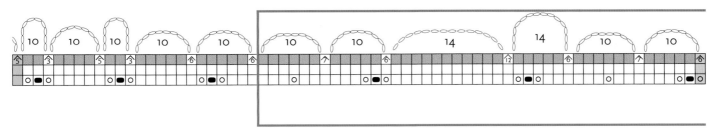

Note: Stitches shaded orange are duplicated for ease of following the two halves of the chart; work the shaded stitches only once.

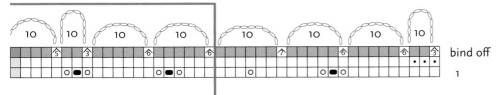

Note: Stitches shaded purple are duplicated for ease of following the two halves of the chart; work the shaded stitches only once.

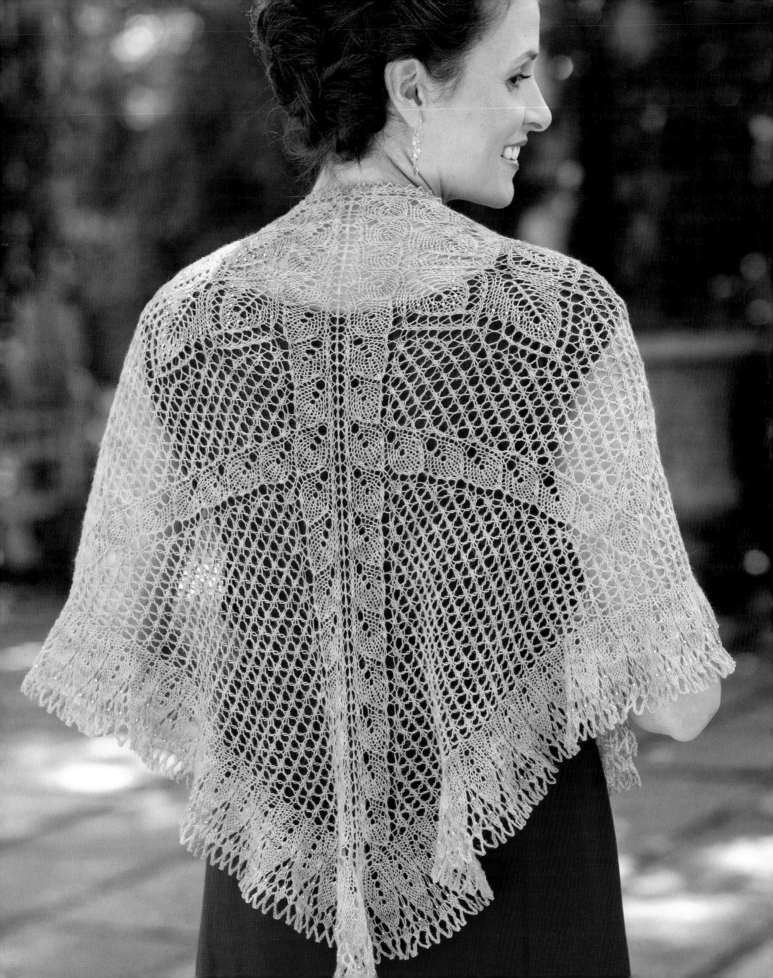

Sunflower Trio

The doily, triangle, and blanket in this collection demonstrate how you can go from a triangle shawl to a full square, or the other way around. The only real difference between the elements of the two larger pieces is the top edge of the triangle. This design, heavily influenced by Marianne Kinzel, who designed lace in the mid-1900s, includes leaf and flower motifs separated by a simple mesh fill. Although these pieces aren't inspired by a particular Kinzel design, they have a similar "feel." Start with the doily if you'd like to practice the techniques on a small piece.

FINISHED SIZE

Doily: About 15" (38 cm) square, blocked; about 14" (35.5 cm) square, after relaxing.

Triangle shawl: About 60" (152.5 cm) wide across top and 30" (76 cm) long at center back, blocked; about 52" (132 cm) wide across top and 26" (66 cm) long at center back, after relaxing.

Square blanket: About 44" (112 cm) square, blocked; about 38" (96.5 cm) square, after relaxing.

YARN

Laceweight (#0 Lace).

Shown here:

Doily: DMC #5 Craft Thread (100% cotton; 10 yd [9 m]/skein): #6132 (A), 3 skeins.

DMC Pearl Cotton #5 (100% cotton; 27.3 yd [25 m]/5 g): #745 (B), #727 (C), #726 (D), and #436 (F), 1 skein each; #725 (E), 2 skeins (you'll need 200 yd (183 m) total if using a single color).

Triangle shawl: Madelinetosh Prairie (100% superwash merino; 840 yd [768 m]/114 g): Gilded, 1 skein.

Square blanket: Madelinetosh Prairie (100% superwash merino; 840 yd [768 m]/114 g): Candlewick, 2 skeins.

NEEDLES

Doily: U.S. size 1 (2.25 mm): set of 5 double-pointed (dpn) and 16" (40 cm) circular (cir).

Triangle shawl: U.S. size 4 (3.5 mm): 40" (100 cm) circular (cir).

Square blanket: U.S. size 4 (3.5 mm): set of 5 double-pointed (dpn) and 16" , 24" , and 40" (40, 60, and 100 cm) circular (cir).

Adjust needle size if necessary to obtain the correct gauge.

NOTIONS

Size 14 (0.75 mm) steel crochet hook, or size to fit beads (shawl and blanket only); about 10 g 8/0 Japanese seed beads for shawl (shown in apricot permanent galvanized); about 20 g 8/0 Japanese seed beads for blanket (shown in permanent gold); 12" (30.5 cm) smooth waste yarn for provisional cast-on for shawl; stitch marker (m); size 4 (2 mm) steel crochet hook for bind-off; tapestry needle; flexible blocking wires for shawl and blanket; T-pins; spray starch for doily (optional).

GAUGE

Doily: 16 sts and 24 rnds = 2" (5 cm) according Doily Chart, worked in rnds and relaxed after blocking.

Triangle shawl: 8 sts and 12 rows = 2" (5 cm) according to Sunflower Chart B, relaxed after blocking.

Square blanket: 8 sts and 12 rnds = 2" (5 cm) according Sunflower Chart B, worked in rnds and relaxed after blocking.

Notes

Repeat each charted row four times per round.

If using assorted colors, begin with lightest and progress to the darkest, joining the darkest color just before beginning the bind-off. Use the Russian method (see page 24) to join new yarn at color changes.

The bind-off begins two stitches before the end of the last round and is included in the chart.

Use spray starch to add stiffness to the doily, if desired.

Doily

With A and dpn, use the long-tail method (see page 19) to cast on 12 sts. Divide sts evenly on 4 dpn so that there are 3 sts on each needle. Place marker and join for working in rnds, being careful not to twist sts. Slip marker every rnd.

Knit 2 rnds.

Work Rnds 1–18 of Sunflower Doily chart, changing to cir needle when there are too many sts to fit comfortably on dpn—80 sts.

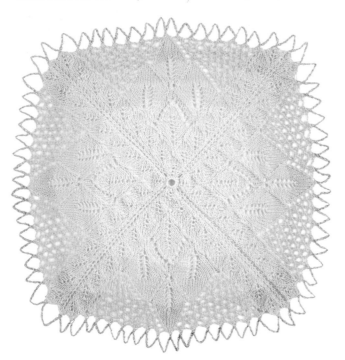

Change to B and work Rnds 19–24—112 sts.

Change to C and work Rnds 25–40—176 sts.

Change to D and work Rnds 41–56—240 sts.

Change to E and work Rnds 57–72, ending last rnd 2 sts before end of rnd—304 sts.

Change to F and, with larger crochet hook, use the gathered crochet method (see page 17) to BO all sts as foll: *gather 5, chain 10, gather 7, chain 10, [gather 4, chain 8] 6 times, [gather 3, chain 8] 3 times, [gather 4, chain 8] 5 times, gather 4, chain 10, gather 7, chain 10; rep from * 3 more times. Secure the final chain st to first group of gathered sts with a slip st.

Cut yarn, leaving a 9" (23 cm) tail. Pull tail through rem loop to secure.

FINISHING

Weave in loose ends but do not trim the tails.

Soak in cool water for at least 30 minutes. Roll in a towel to remove excess water.

Place on flat padded surface, stretch to finished measurements, and pin out each crochet loop. Apply spray starch if desired.

Allow to air-dry completely before removing pins.

Trim tails on woven-in ends.

□	knit	☒	sssk
·	purl	Ⓢ	gather 3
☒	k1tbl	⬆	gather 4
O	yo	Ⓢ	gather 5
⬇	[k1, p1, k1] in same stitch	⬆	gather 7
M	M1 without twist (see page 24)	▢	knit, except on last rep, do not work these stitches, shifting the beg of rnd to the right
☑	k2tog		
╲	ssk	▨	no stitch
⋀	s2kp	0	crochet chain
▬	place bead	☐	pattern repeat
☒	k3tog		

Sunflower Doily Chart

bind off

71
69
67
65
63
61
59
57
55
53
51
49
47
45
43
41
39
37
35
33
31
29
27
25
23
21
19
17
15
13
11
9
7
5
3
1

4 times

Notes

A circular needle is used to accommodate the large number of sts. Do not join; work back and forth in rows.

For Sunflower Charts A, B, C, and D, work the 3 garter stitches outside the red repeat box, work the red repeat box once, knit or purl the center spine stitch through the back loop, work the red repeat box once more, then work the final 3 garter stitches outside the red repeat box.

Beads are applied with smaller crochet hook (see page 16).

Triangle Shawl

Using a provisional method (see page 19), CO 3 sts.

Knit 7 rows—3 garter ridges on RS. Do not turn after working the last row.

Turn work 90 degrees and pick up and purl (see page 25) 3 sts along selvedge (1 st in each garter ridge), carefully remove waste yarn from provisional CO and knit the 3 exposed sts—9 sts total.

Work Rows 1–26 of Sunflower Set-Up Chart—61 sts.

Knitting the first 3 and last 3 sts of every row and working spine sts through the back loop (tbl; see Notes), work Rows 27–66 of Sunflower A chart, adding beads with smaller crochet hook (see page 16) as specified—141 sts.

Work Rows 67–98 of Sunflower Chart B—205 sts.

Work Rows 99–114 of Sunflower Chart C—237 sts.

Work Rows 115–138 of Sunflower Chart D—285 sts.

Work Rows 139–156 of Sunflower Triangle Border chart—849 sts.

With larger crochet hook, use the gathered crochet method (see page 17) to BO as foll: *gather 3, chain 6; rep from * to last 3 sts, gather 3.

Cut yarn, leaving a 9" (23 cm) tail. Pull tail through rem loop to secure.

FINISHING

Weave in loose ends but do not trim tails.

Soak in cool water for at least 30 minutes. Roll in a towel to remove excess water.

Weave flexible blocking wires into garter bumps along straight top edge and through each crochet loop along the diagonal sides. Place on flat padded surface and pin out wires to finished dimensions.

Allow to air-dry thoroughly before removing wires and pins.

Trim tails on woven-in ends.

☐ knit on RS, purl on WS	╱ k2tog
• purl on RS, knit on WS	╲ ssk
ℓ k1tbl on RS, p1tbl on WS	⋏ s2kp
O yo	■ place bead
[k1, p1, k1] in same stitch	▨ no stitch
M M1 without twist (see page 24)	☐ pattern repeat

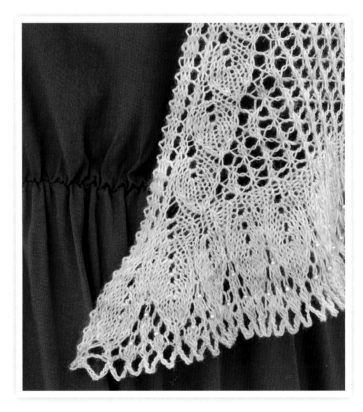

Sunflower Set-Up Chart

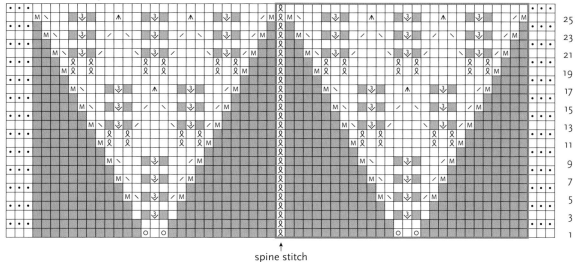

spine stitch

Work whole chart once for triangle shawl.

Work only the sts in the red box 4 times for square blanket.

Sunflower Chart A

The center twisted "spine" stitch is not included on the charts A,
B, C, or D; maintain it by knitting or purling tbl.

Work whole chart for triangle shawl, working red box twice,
working the twisted spine stitch between the repeats.

Work only the sts in the red box 4 times for square blanket,
working the twisted spine stitch between the repeats.

Sunflower Chart B

Work whole chart for triangle shawl, working red box twice, working the twisted spine stitch between the repeats.

Work only the sts in the red box 4 times for square blanket, working the twisted spine stitch between the repeats.

Note: Stitches shaded blue are duplicated for ease of following the two halves of the chart; work the shaded stitches only once.

Sunflower Chart C

Work whole chart for triangle shawl, working red box twice, working the twisted spine stitch between the repeats.

Work only the sts in the red box 4 times for square blanket, working the twisted spine stitch between the repeats.

Work the blue boxes 5 times on each repeat of the red box.

Note: Stitches shaded green are duplicated for ease of following the two halves of the chart; work the shaded stitches only once.

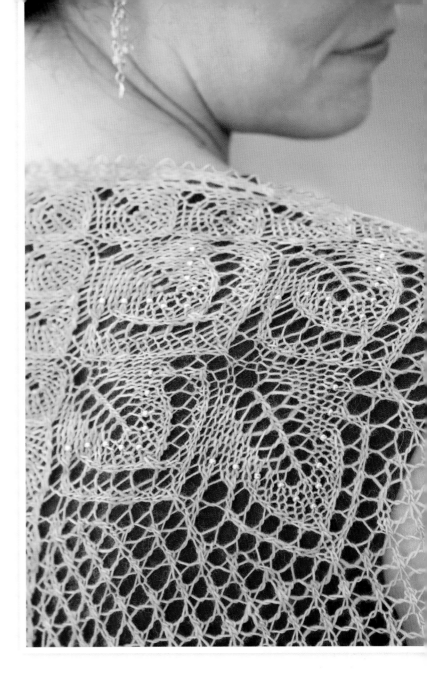

Chart (rows 67–97):

97
95
93
91
89
87
85
83
81
79
77
75
73
71
69
67

Chart (rows 99–113):

113
111
109
107
105
103
101
99

Legend:

- ☐ knit on RS, purl on WS
- ⦁ purl on RS, knit on WS
- ℞ k1tbl on RS, p1tbl on WS
- ○ yo
- ⤓ [k1, p1, k1] in same stitch
- Ⓜ M1 without twist (see page 24)
- ╱ k2tog
- ╲ ssk
- ⋏ s2kp
- ▬ place bead
- ▨ no stitch
- ☐ large pattern repeat
- ☐ small pattern repeat

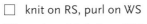

Sunflower Chart D

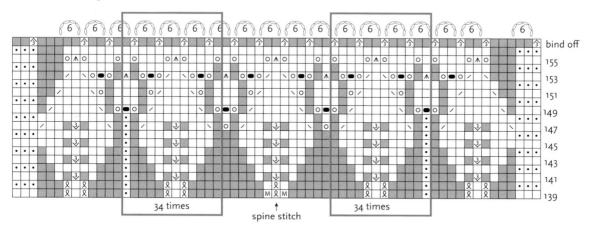

Work whole chart for triangle shawl, working red box twice, working the twisted spine stitch between the repeats.

Work only the sts in the red box 4 times for square blanket, working the twisted spine stitch between the repeats.

Work the blue boxes 9 times on each repeat of the red box.

Sunflower Triangle Border Chart

☐	knit on RS, purl on WS	⬆	s2kp
⬝	purl on RS, knit on WS	◼	place bead
⼊	k1tbl on RS, p1tbl on WS	⬆	gather 3
○	yo	☐	no stitch
⬇	[k1, p1, k1] in same stitch	0	crochet chain
Ⓜ	M1 without twist (see page 24)	☐	large pattern repeat
⟋	k2tog	☐	small pattern repeat
⟍	ssk		

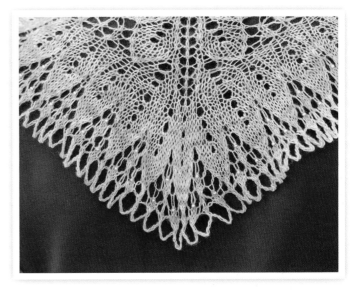

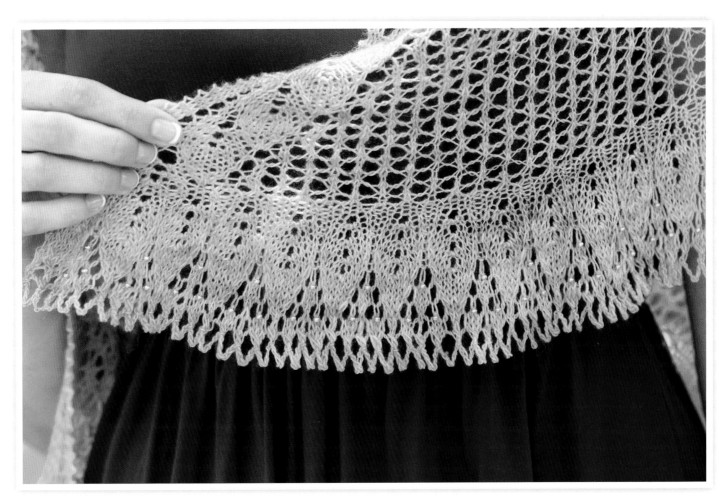

Notes

For the Sunflower Set-Up, A, B, C, and D charts, just the red repeat box 4 times per round. Do not work the stitches outside the repeat box.

Beads are applied with smaller crochet hook (see page 16).

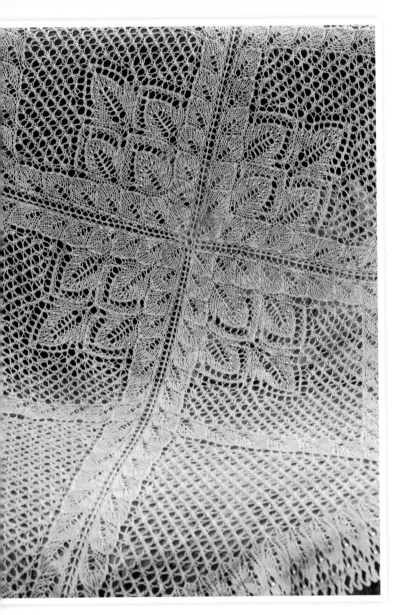

Square Blanket

With dpn and using the long-tail method (see page 19), CO 8 sts. Divide sts evenly on 4 dpn so that there are 2 sts on each needle. Join for working in rnds, being careful not to twist sts.

Knit 1 rnd, working all sts through the back loop (tbl; see page 26) to form twisted sts.

Cont as foll, changing to longer cir needles when sts no longer fit on the current needles.

Work Rnds 1–26 of Sunflower Set-Up Chart—112 sts.

Working spine sts tbl, work Rnds 27–66 of Sunflower Chart A, adding beads with smaller crochet hook (see page 16) as specified—272 sts.

Work Rnds 67–98 of Sunflower Chart B—400 sts.

Work Rnds 99–114 of Sunflower Chart C—464 sts.

Work Rnds 115–138 of Sunflower Chart D—560 sts.

Work Rnds 139–156 of Sunflower Square Border Chart—1,728 sts.

With larger crochet hook, use the gathered crochet method (see page 17) to BO as foll: *gather 3, chain 6; rep from * to end, join last chain st to the first gather-3 group with a slip st.

Cut yarn, leaving a 9" (23 cm) tail. Pull tail through rem loop to secure.

FINISHING

Weave in loose ends but do not trim tails.

Soak in cool water for at least 30 minutes. Roll in a towel to remove excess water.

Weave flexible blocking wires through crochet loops on all four sides, omitting the corner loops. Place on flat padded surface, pin out corner loops, and pin out wires to finished dimensions.

Allow to air-dry thoroughly before removing wires and pins.

Trim tails on woven-in ends.

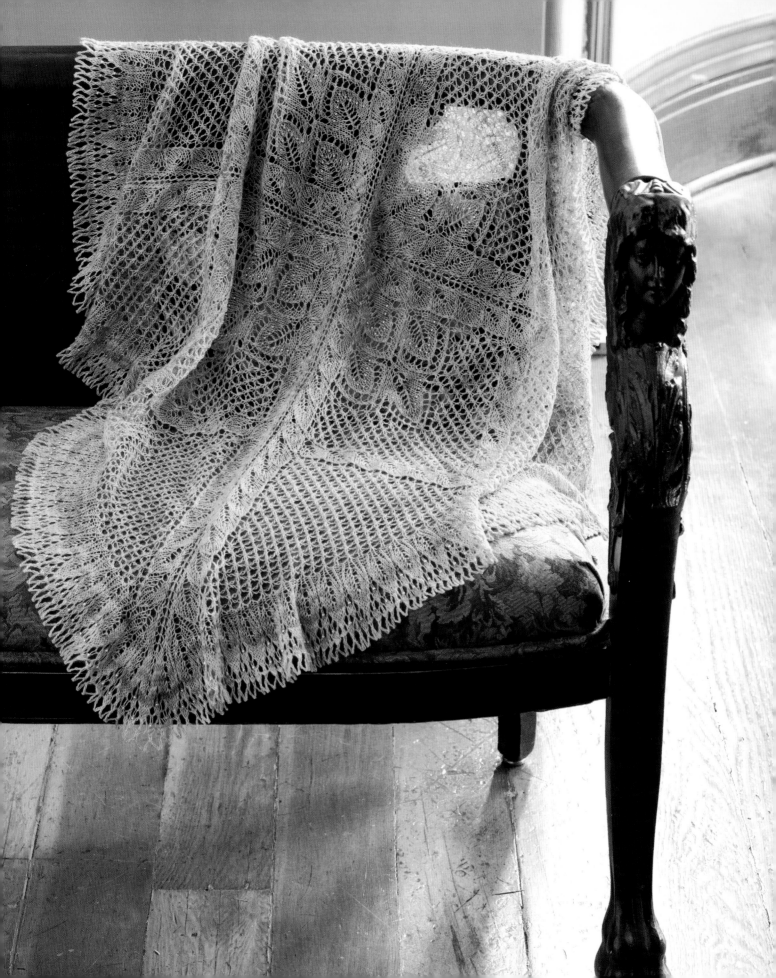

Sunflower Square Border Chart

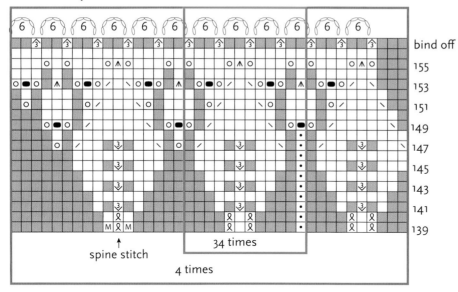

- ☐ knit
- · purl
- knit k1tbl
- ○ yo
- [k1, p1, k1] in same stitch
- M M1 without twist (see page 24)
- ╱ k2tog
- ╲ ssk
- ⋀ s2kp
- ● place bead
- gather 3
- no stitch
- 0 crochet chain
- ☐ large pattern repeat
- ☐ small pattern repeat

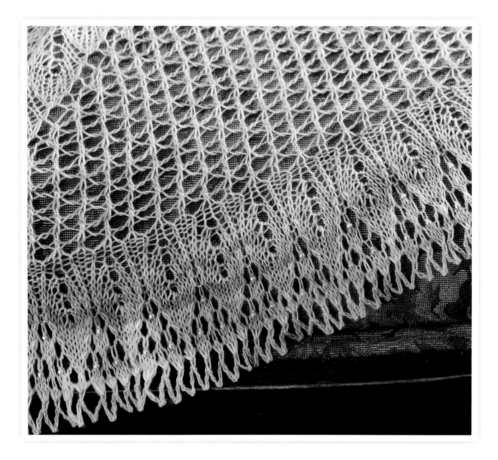

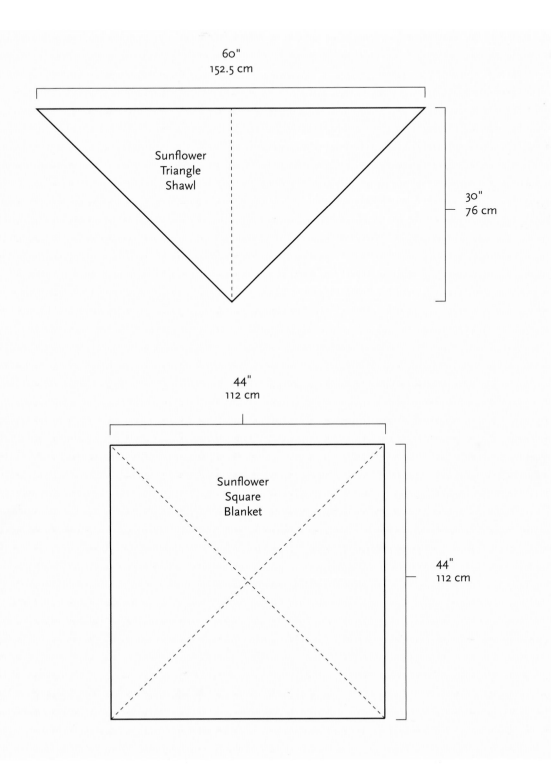

60"
152.5 cm

Sunflower
Triangle
Shawl

30"
76 cm

44"
112 cm

Sunflower
Square
Blanket

44"
112 cm

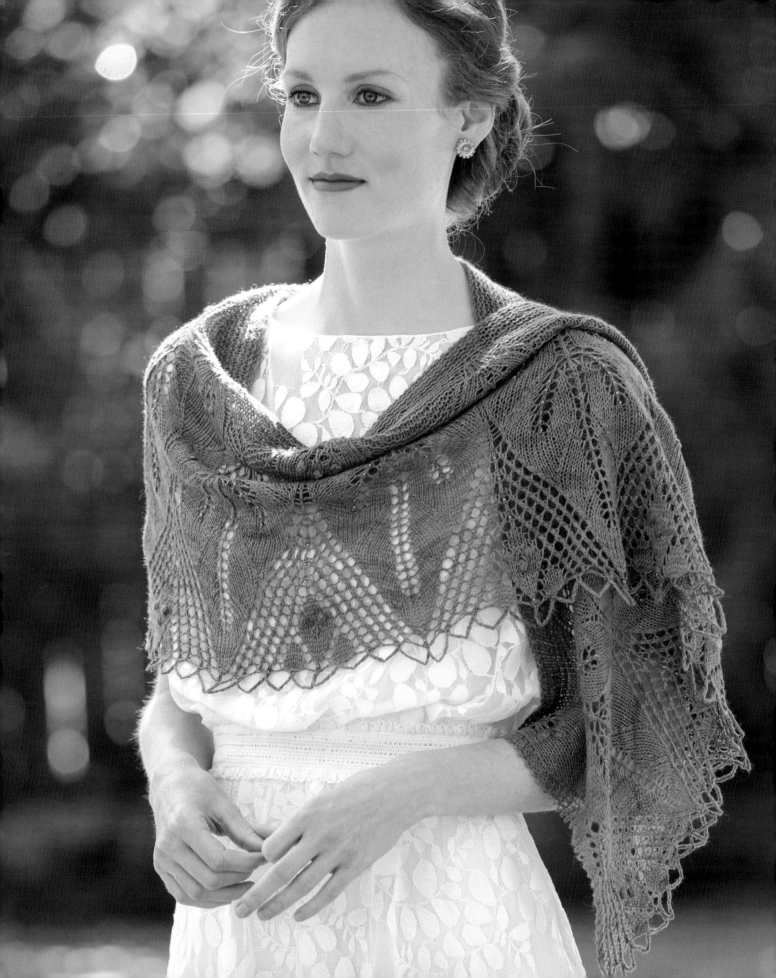

Diospyros Wrap

For this wrap, I combined several leaf forms commonly used in vintage art lace tablecloths. I modified the leaf motifs by omitting increases, which allows the piece to arc gently rather than forming a full circle. For texture, I added nupps (Estonian bobbles) in the leaf motifs, used beads to highlight the stems of the larger leaves, and used a directional linear fill-mesh between motifs.

FINISHED SIZE

About 70" (178 cm) wide and 17" (43 cm) long at center back, blocked; about 62" (157.5 cm) wide and 15" (38 cm) long at center back, after relaxing.

YARN

Laceweight (#0 Lace).

Shown here: Jade Sapphire Silk/Cashmere 2-ply (55% silk, 45% Mongolian cashmere; 400 yd [366 m]/55 g): #148 Elysian Fields, 2 skeins.

NEEDLES

U.S. size 4 (3.5 mm): 40" (100 cm) circular (cir).

Adjust needle size if necessary to obtain the correct gauge.

NOTIONS

About 20 g of 8/0 Miyuki Japanese seed beads (shown in #457 metallic dark bronze); size 14 (0.75 mm) steel crochet hook (or size to fit beads); size 4 (2 mm) steel crochet hook for bind-off; tapestry needle; flexible blocking wires; T-pins; 6" (15 cm) stick pin (pin shown is MEI FA hair sticks from Shaunebazner.com).

GAUGE

9 sts and 16 rows = 2" (5 cm) in garter st, relaxed after blocking.

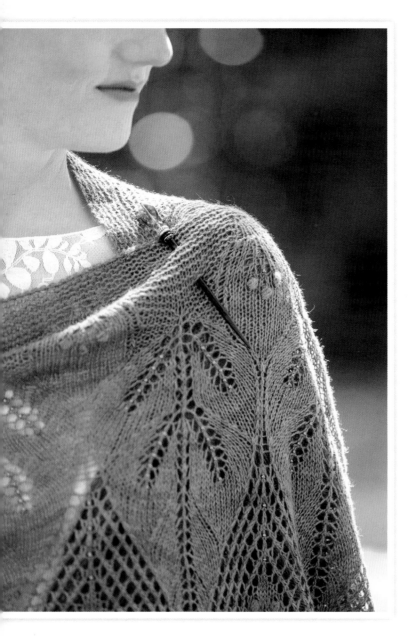

WRAP

Using the cable method (see page 20), CO 250 sts. Do not join. Work back and forth in rows.

Knit 2 rows—1 garter ridge.

Work short-rows as foll:

Short-Row 1: With RS facing, knit to last 20 sts, turn work so WS is facing, sl 1 knitwise with yarn in back (kwise wyb) knit to last 20 sts, turn work.

Short-Row 2: With RS facing, sl 1 kwise wyb, knit to last 40 sts, turn work so WS is facing, sl 1 kwise wyb, knit to last 40 sts, turn work.

Short-Row 3: With RS facing, sl 1 kwise wyb, knit to last 60 sts, turn work so WS is facing, sl 1 kwise wyb, knit to last 60 sts, turn work.

Short-Row 4: With RS facing, sl 1 kwise wyb, knit to last 80 sts, turn work so WS is facing, sl 1 kwise wyb, knit to last 80 sts, turn work.

Short-Row 5: With RS facing, sl 1 kwise wyb, knit to last 100 sts, turn work so WS is facing, sl 1 kwise wyb, knit to last 100 sts, turn work.

Short-Row 6: With RS facing, sl 1 kwise wyb, knit to last 120 sts, turn work so WS is facing, sl 1 kwise wyb, knit to last 120 sts, turn work.

Next row: With RS facing, sl 1 kwise wyb, knit to end.

Next row: (WS) Knit.

Adding beads with smaller crochet hook (see page 16) as specified, work Rows 1–84 of Diospyros chart—437 sts.

With the larger crochet hook, use the gathered crochet method (see page 17) to BO as foll: [gather 3, chain 8] 4 times, gather 7, chain 8, gather 3, chain 8, *gather 7, chain 8, [gather 4, chain 8] 2 times, gather 3, chain 8, [gather 4, chain 8] 2 times, gather 7, chain 8, gather 3, chain 8; rep from * 10 more times, gather 7, chain 8, [gather 3, chain 8] 3 times, gather 3.

Cut yarn, leaving a 9" (23 cm) tail. Pull tail through rem loop to secure.

FINISHING

Weave in loose ends but do not trim tails.

Soak in cool water for at least 30 minutes. Roll in a towel to remove excess water.

Weave flexible wires along top "straight" edge and both selvedges. Place on flat padded surface, stretch to finished measurements, and pin out each chain loop along the BO edge.

Allow to air-dry thoroughly before removing wires and pins.

Trim tails on woven-in ends.

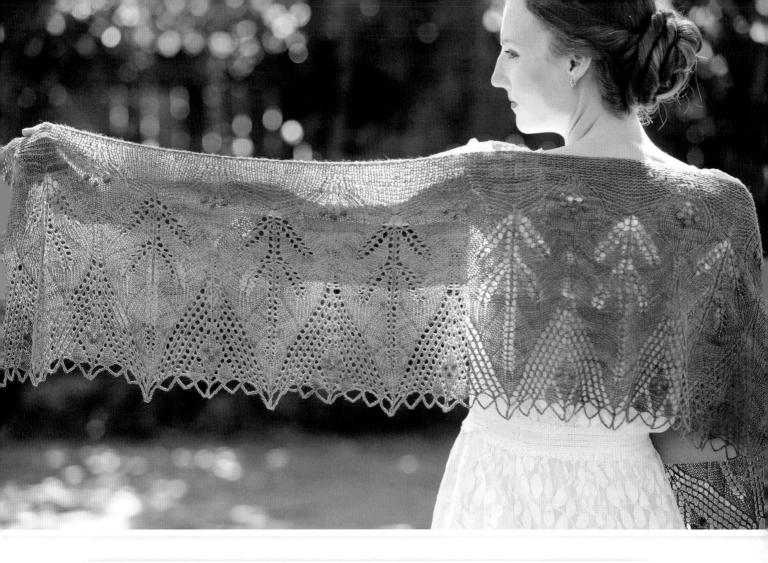

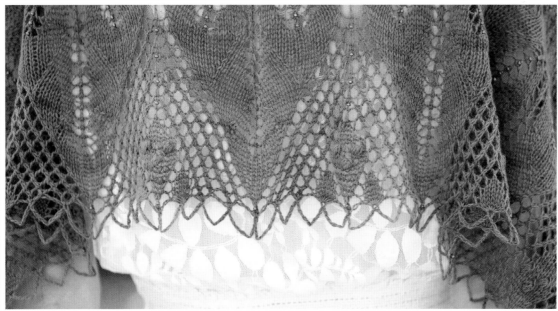

Diospyros Chart

□ knit on RS, purl on WS

· purl on RS, knit on WS

Ⱥ k1tbl on RS, p1tbl on WS

↯ [k1, p1] in same stitch

◹ ssk

◸ k2tog

○ yo

▣ place bead

↯ [k1, yo, k1, yo, k1, yo, k1, yo, k1] in same stitch

⁹ p9tog

⊥ pick up and knit 1 st from between the sts, 3 rows below

▲ s2kp

▥ s2kp, place bead

⌃ gather 3

⌃ gather 4

⌃ gather 7

▦ no stitch

0 crochet chain

□ pattern repeat

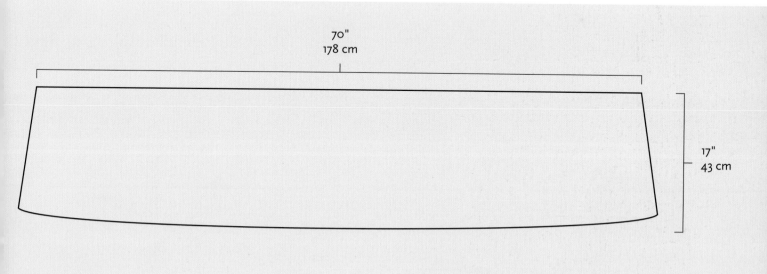

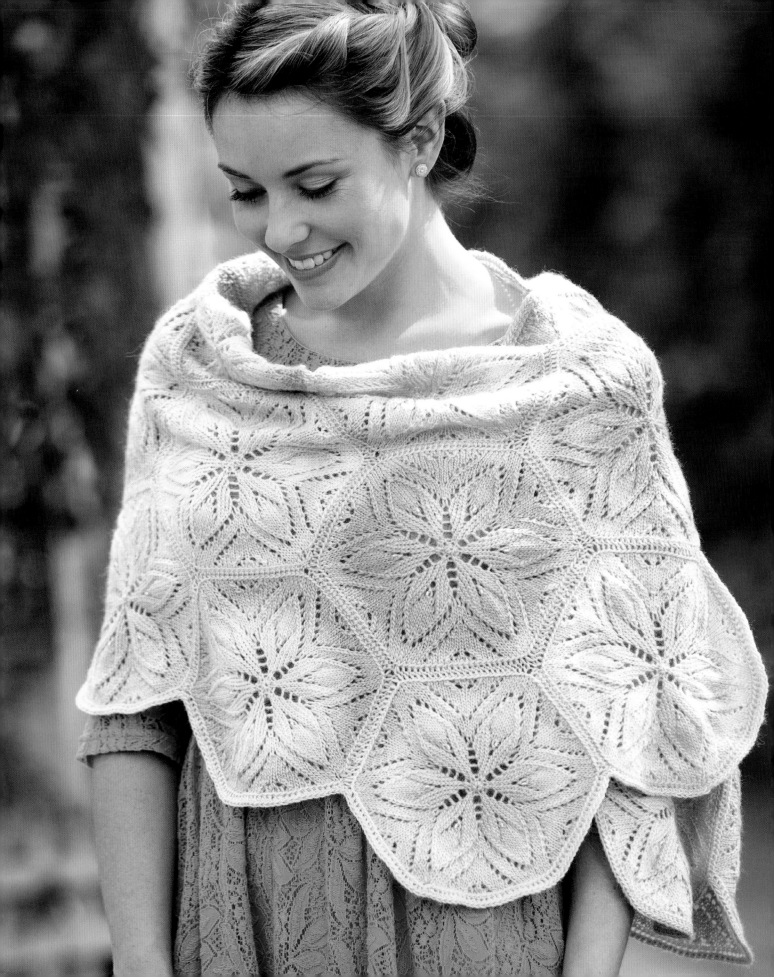

Sand Dollar Wrap

I took inspiration from an assortment of traditional six-wedge doilies for the lace pattern in this generous wrap. Although sand dollars typically have five petals, the modules of this piece remind me of the sea, and the reference feels right to me despite that technical flaw! The lace pattern reads clearly in the long color repeats of this variegated yarn, but you could substitute a solid color if you prefer.

FINISHED SIZE

About 22½" (57 cm) wide and 64" (162.5 cm) long.

YARN

Fingering weight (#1 Super Fine).

Shown here: Crystal Palace Mini Mochi (80% merino, 20% nylon; 195 yd [178 m]/50 g): #312 Sea Foam, 6 balls.

NEEDLES

Body: U.S. size US 3 (3.25 mm): set of four 6" (15 cm) double-pointed (dpn) and 16" (40 cm) circular (cir).

Bind-off: U.S. size 5 (3.75 mm): 1 needle of any type.

Blocking: U.S. size 1 (2.25 mm): six 8" (20.5 cm) or longer dpn (alternatively, you can use short, rigid blocking wires).

Adjust needle size if necessary to obtain the correct gauge.

NOTIONS

About 20 g (132 beads total) size 6/0 Japanese seed beads, shown in Pale Blue lined Clear AB; stitch marker (m); size 14 (0.75 mm) steel crochet hook, or size to place beads; tapestry needle; size F/5 (3.75 mm) crochet hook for final edging; T-pins.

GAUGE

Each hexagon measures 8" (20.5 cm) wide, 9" (23 cm) along the diagonal, and 4½" (11.5 cm) along each of the six sides, after blocking.

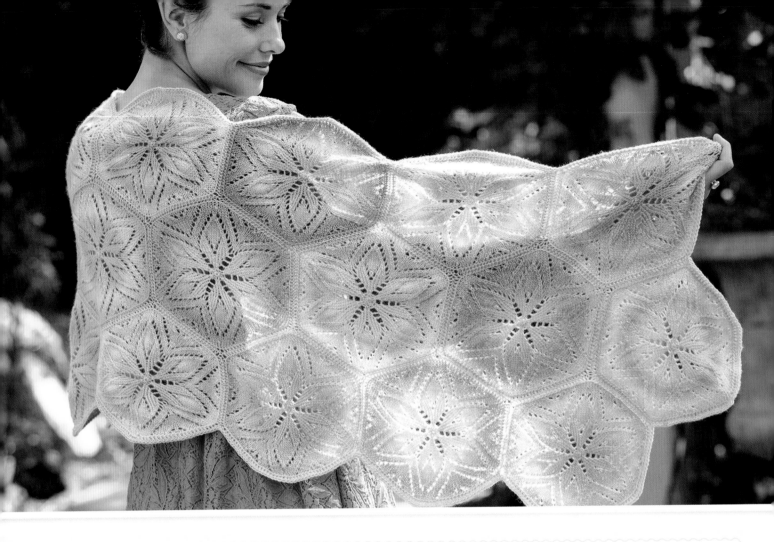

Notes

This wrap is composed of twenty-two individual hexagons that are worked in rounds from the center out. The chart is repeated six times per round (twice on each of three needles). Use the cast-on tail to indicate the beginning of the round.

Note that on Rnds 4, 6, and 8 of the chart, the beginning of the round is shifted one stitch to the left. To do this, knit the first stitch through the back loop at the beginning of the rnd, then work the next stitch as the first stitch of chart for that rnd, working the chart two times across each of the three needles in the same way.

Beads are added with a crochet hook (see page 16).

Change to 16" (40 cm) circular needle when there are too many stitches to fit comfortably on double-pointed needles. Once you switch to the circular needle, you'll need a stitch marker to indicate the beginning of the round.

To ensure a loose bind-off that will allow the piece to be blocked into a proper hexagon, use a needle one or two sizes larger. Block your first hexagon to make sure it's the correct dimensions before knitting the other hexagons.

Each ball of the specified yarn will make four hexagons. Add more hexagons for a baby blanket or throw, keeping in mind that you'll need more yarn to do so.

WRAP

With dpn, use the long-tail method (see page 19) to CO 6 sts.

Divide the sts on 3 dpn so that there are 2 sts on each needle. Join for working in rnds, being careful not to twist sts. Use the tail from the cast-on to indicate the beg of rnd (see page 26).

Knit 1 rnd, working each st through the back loop (k1tbl; see page 26).

Work Rows 1–30 of Sand Dollar Chart, moving the beginning of Rnds 4, 6, and 8 one st to the left (see Notes) and adding beads with smaller crochet hook (see page 16) as specified on Rnd 11—138 sts.

With larger needle and working loosely and evenly, use the lace method (see page 17) to BO as foll: sl 1, k1, then knit these 2 sts tog through their back loops (tbl), *return st just worked to left needle tip, k2togtbl; rep from *.

Cut yarn, leaving a 24" (61 cm) tail. Bring tail through rem loop to secure.

FINISHING

Weave in CO tail to WS. Thread BO tail onto a tapestry needle, attach it to the first BO st, then weave it in a few sts along the WS edge.

BLOCKING

Block each hexagon separately as foll: Weave a separate dpn or blocking wire through the 23 sts along each of the six edges, working in the order that the sts were worked.

With needles or wires in place, soak each hexagon in a pan of warm water for 30 minutes, pressing the hexagon down in the water to ensure complete saturation.

Blot with a small towel to remove as much water as possible.

Lay on a flat padded surface and use a T-pin to block each corner so that each side measures 4½" (11.5 cm) long, the entire piece measures 8" (20.5 cm) long, and each diagonal measures 9" (23 cm).

Allow to air-dry completely before removing pins and wires.

Sand Dollar Chart

Legend:

- ☐ knit
- • purl
- ⅄ [k1, p1] in same stitch
- ⱳ k1tbl
- ○ yo
- ⱳ (shaded) remove beg of rnd m, k1tbl (first st of rnd), then replace m, shifting beg of rnd 1 st to the left
- ● place bead
- ＼ ssk
- ／ k2tog
- ▩ no stitch
- ☐ pattern repeat

6 times

ASSEMBLY

With RS facing and using the BO tail threaded on a tapestry needle, use overhand sts (see page 26) to sew hexagons tog, matching loops made from blocking wires st for st and following the illustration on page 119.

With RS facing and making sure that the BO tails are at opposite ends of the edge, sew one edge of Hexagon 1 to one edge of Hexagon 2, being careful not to pull too tightly. Remove tapestry needle but leave the tail hanging (do not weave in or trim tail).

Sew the opposite edge of Hexagon 2 to Hexagon 3. Cont in this manner for Hexagons 4, 5, 6, 7, and 8, forming a long strip.

Sew Hexagons 9–15 and Hexagons 16–22 into similar strips.

Using the rem BO tails, sew the three strips together in the same way, adding more seaming yarn as needed.

EDGING

With larger crochet hook and a new ball of yarn, work 1 row of sc (see page 21) around the entire perimeter, working into the loops created by blocking wires, being careful not to work to tightly, and working 2 sc in each seam (1 sc in each side of the seam).

Cut yarn, leaving a 9" (23 cm) tail. Bring tail through rem loop to secure.

Weave in loose ends but do not trim tails.

Place on a flat padded surface, arrange to finished measurements, and cover with a damp towel (or lightly steam). Remove the towel after piece is nice and damp and allow to air-dry thoroughly before moving.

Trim tails on woven-in ends.

Secure with a clasp or shawl pin.

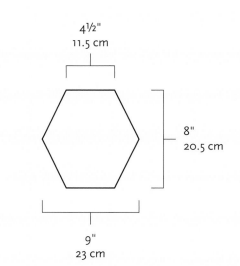

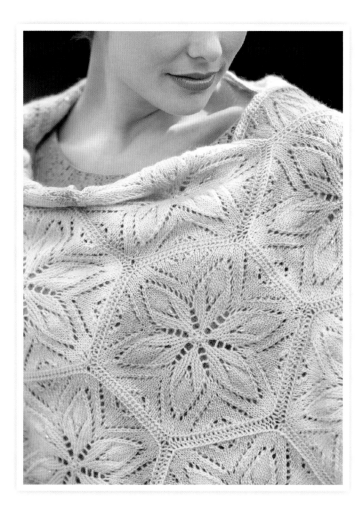

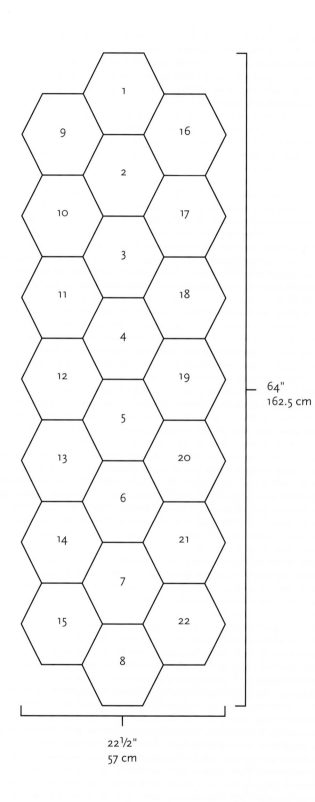

64"
162.5 cm

22$\frac{1}{2}$"
57 cm

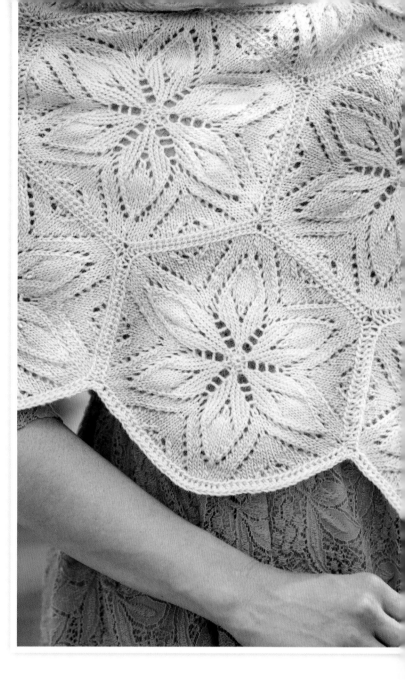

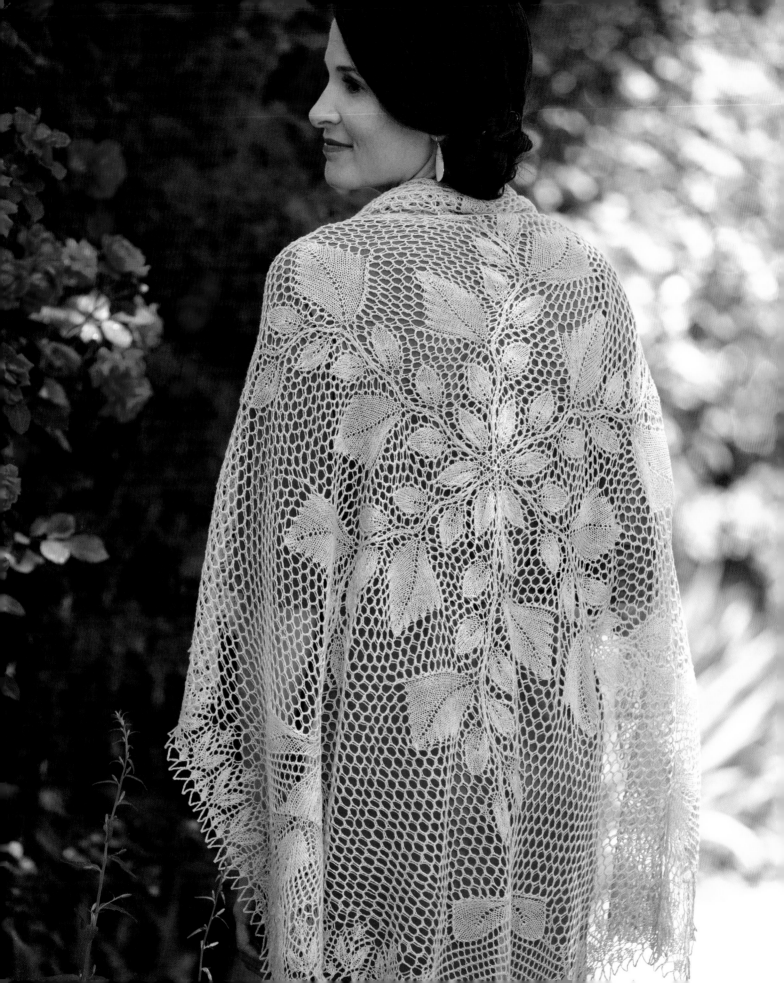

Ghost Orchid

Perhaps the most challenging project in this book, this circular wrap (or throw) has a hex-mesh fill, a directional linear mesh around the large orchid motif, and small bobbles, called nupps, above the orchids. The center of this piece was inspired by various leaf and flower motifs used in several doilies from the 1959 German publication *Elsa Kunststrickheft* and a doily in an undated pamphlet (#7008) from the Mez thread company. No attribution is given to the designer in either out-of-print publication. I suspect that all of the pieces that inspired me were designed by Herbert Niebling, but I can't be sure.

FINISHED SIZE

About 60" (152.5 cm) in diameter, blocked; about 58" (147.5 cm) in diameter, after relaxing.

YARN

Laceweight (#0 Lace).

Shown here: Colourmart 2/28 wool/silk (50% fine wool, 50% silk; 2,300 yd [2,103 m]/150 g): Oatmeal, 1 cone.

NEEDLES

U.S. size 2 (2.75 mm): 16", 24", 32", and 40" (40, 60, 80, and 100 cm) circular (cir) and set of 5 double-pointed (dpn).

Adjust needle size if necessary to obtain the correct gauge.

NOTIONS

Stitch markers (m; see Notes); tapestry needle; size 4 (2 mm) steel crochet hook for bind-off; tapestry needle; six flexible blocking wires; T-pins.

GAUGE

10 sts and 18 rnds = 2" (5 cm) according to the hex-mesh motif in Ghost Orchid Chart D, worked in rnds and relaxed after blocking.

Notes

A great yarn alternative that can be worked at the same gauge is Jade Sapphire Lacey Lamb (100% fine merino; 825 yd/55 g): Oatmeal #601, 2 balls.

For this complicated pattern, I suggest placing a marker between each of the six pattern repeats. On rounds where the beginning of the round shifts, you'll need to shift each marker accordingly. It's also a good idea to use string-loop markers (see page 26) between each small pattern repeat of the Ghost Orchid Chart E.

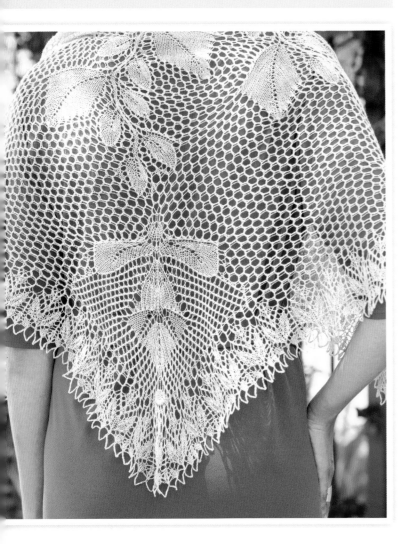

SHAWL

With dpn, CO 6 sts. Divide sts evenly on 3 dpn so that there are 2 sts on each needle. Join for working in rnds, being careful not to twist sts. Place a marker to indicate beg of rnd and an additional marker between each pattern rep.

Changing to progressively longer cir needles as necessary, work Rnds 1–36 of Ghost Orchid Chart A—204 sts.

Work Rnds 37–82 of Ghost Orchid Chart B—438 sts.

Work Rnds 83–116 of Ghost Orchid Chart C—384 sts.

Work Rnds 117–174 of Ghost Orchid Chart D—762 sts.

Work Rnds 175–199 of Ghost Orchid Chart E, placing additional markers to indicate each patt rep and ending 2 sts before beg-of-rnd marker on Rnds 175 and 199—1,440 sts.

With crochet hook, use the gathered crochet method (see page 17) to BO as foll: [gather 4, chain 8, gather 4, chain 8, gather 3, chain 8, gather 4, chain 8] 96 times, then join last chain st to the first BO st with a slip st.

Cut yarn, leaving a 9" (23 cm) tail. Pull through rem loop to secure.

FINISHING

Weave in loose ends but do not trim tails.

Soak in cool water for at least 30 minutes. Roll in a towel to remove excess water.

Weave a separate flexible blocking wire through the crochet BO loops on each of the six edges, excluding the six crochet loops on each of the six points. Place on flat padded surface, stretch to finished measurements, and pin out the wires (the wires will form gently curved lines) as well as each of six loops at each point to form a hexagon.

Allow to air-dry thoroughly before removing wires and pins.

Trim tails on woven-in ends.

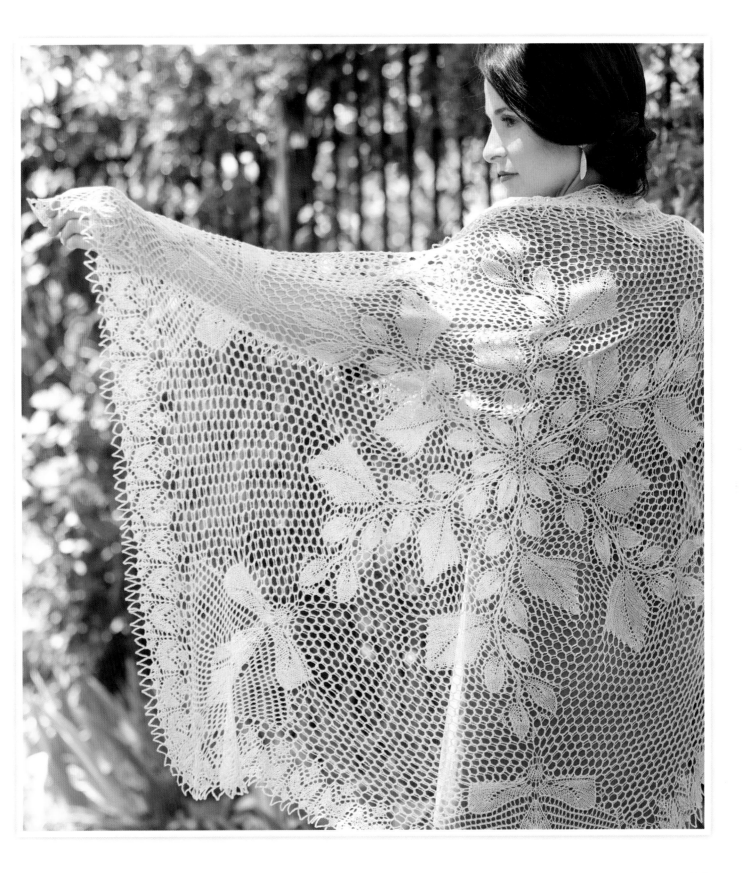

Ghost Orchid Chart A

6 times

Ghost Orchid Chart B

6 times

Note: Stitches shaded blue are duplicated for ease of following the two halves of the chart; work the shaded stitches only once.

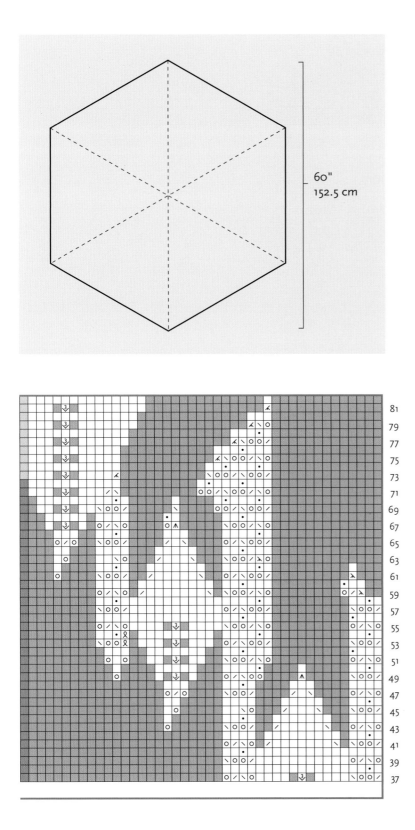

60"
152.5 cm

☐	knit
⋅	purl
O	yo
⟍	ssk
⟋	k2tog
⤵	[k1, p1, k1] in same stitch
☒	k1tbl
⋀	s2kp
⟋⟍	sssk
⟋⟍	k3tog
☐	knit on all reps except the last rep; end rnd 1 or 2 sts before end of rnd, replace beg of rnd marker before these stitches, shifting beg of rnd 1 or 2 sts to the right
⑤	k5tog
▨	no stitch
0	crochet chain
☐	pattern repeat

Row numbers on chart: 81, 79, 77, 75, 73, 71, 69, 67, 65, 63, 61, 59, 57, 55, 53, 51, 49, 47, 45, 43, 41, 39, 37

Ghost Orchid Chart C

6 times

Note: Stitches shaded blue are duplicated for ease of following the two halves of the chart; work the shaded stitches only once.

Ghost Orchid Chart D

2 times

6 times

Note: Stitches shaded green are duplicated for ease of following the two halves of the chart; work the shaded stitches only once.

Chart (rows 83–115):
115
113
111
109
107
105
103
101
99
97
95
93
91
89
87
85
83

☐ knit

• purl

☐o yo

☐\ ssk

☐/ k2tog

⤓ [k1, p1, k1] in same stitch

ℛ k1tbl

⋀ s2kp

⋋ sssk

⋌ k3tog

▨ knit on all reps except the last rep; end rnd 1 or 2
stitches before end of rnd, replace beg of rnd marker
before these stitches, shifting beg of rnd 1 or 2 sts to the right

⑤ k5tog

▪ remove beg of rnd m, knit first st of rnd, then replace m,
shifting beg of rnd 1 st to the left

Ⓜ M1 without twist (see page 24)

⑤ [k1, p1, k1, p1, k1] in same stitch

⑦ k7tog

⑦ [k1, yo, k1, yo, k1, yo, k1] in same stitch

③ gather 3

④ gather 4

▪ no stitch

0 crochet chain

☐ small pattern repeat

☐ large pattern repeat

Chart (rows 117–173):
173
171
169
167
165
163
161
159
157
155
153
151
149
147
145
143
141
139
137
135
133
131
129
127
125
123
121
119
117

7 times

Ghost Orchid Chart E

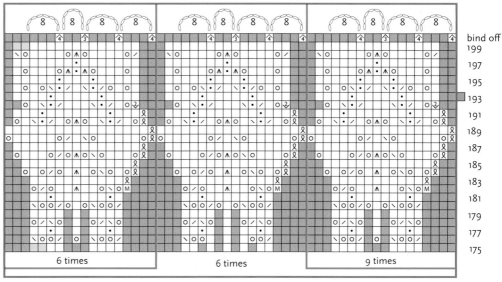

bind off
199
197
195
193
191
189
187
185
183
181
179
177
175

6 times 6 times 9 times

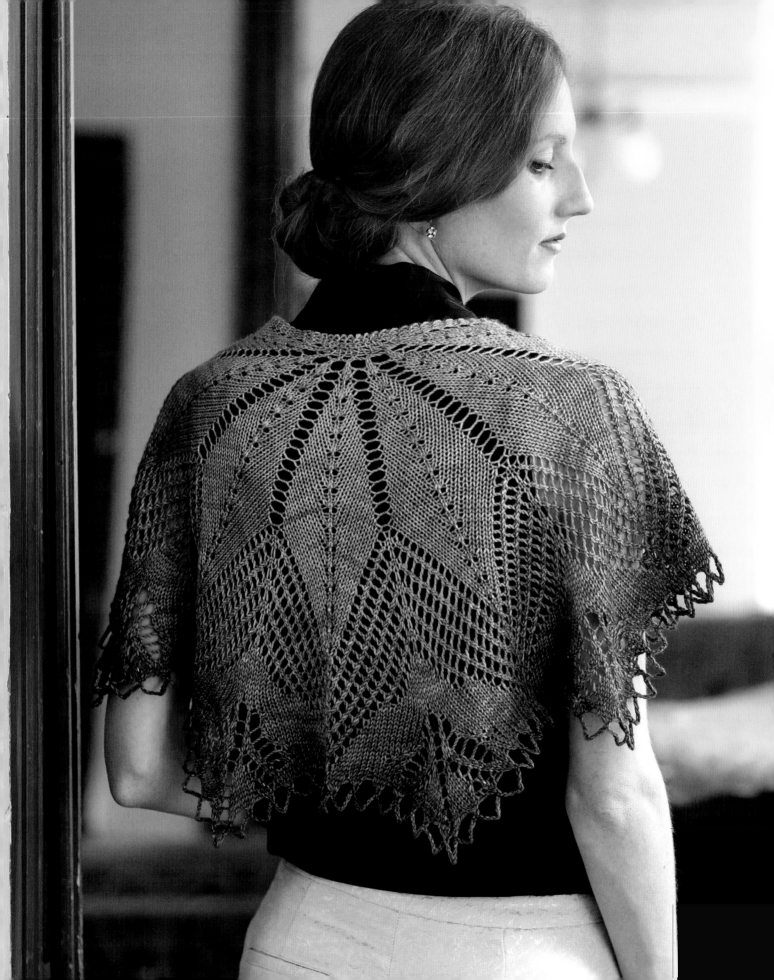

CHAPTER 5:
Doily Dissection
A Little Geometry and a Lot of Fun

Are you ready to design your own shawl? Let's walk through the process I use so you can see the steps and the points at which I make design choices. You can either design your own doily or start with one in your pattern library.

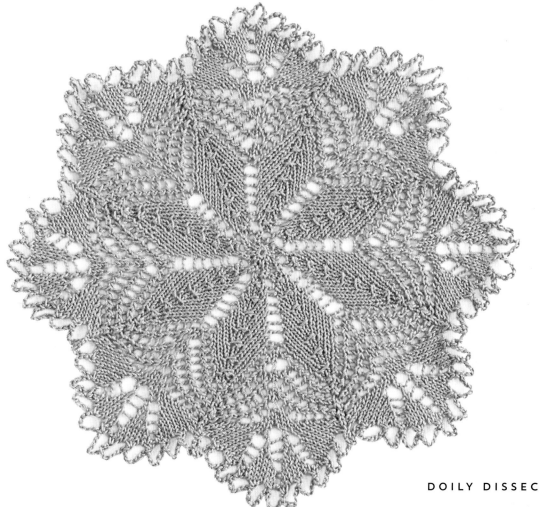

For the shawlette shown on page 128, I began with a small doily from a DMC publication from around 1922 that I found online and in the public domain (see Bibliography). The original pattern was for a ten-wedge doily, and the instructions were written out line by line.

Step 1: Draw a chart

My first step was to translate the instructions into a chart. I prefer charts because they let me see how yarnovers and decreases are arranged across a row and how they're aligned from one row to the next. Any errors in stitch counts or alignment—which are quite common in vintage patterns—are much easier to see in a chart than in row-by-row instructions. Once the pattern has been charted (and corrected), I can modify separate elements of the design as necessary.

The original chart for the DMC doily shown at lower left reveals that the lace patterning (yarnovers and decreases) is worked on both even- and odd-numbered rows, and that increases within each wedge are worked every third row. This type of pattern is quite easy to work in rounds, in which every

Original Ten-Wedge Doily Chart

Yarnovers and decreases are worked on both right- and wrong-side rows in the original ten-wedge chart.

Note: These charts are for illustration purposes only and are not meant to be knit from.

Modified Ten-Wedge Doily Chart

In this modified chart, all decreases have been moved to right-side (even-numbered) rows.

row of the chart is essentially a right-side row and is read from right to left. But it's much more difficult to translate for working back and forth in rows for a shawl, in which you must alternate between right- and wrong-side rows and for which you must read the chart from right to left on right-side rows and from left to right on wrong-side rows.

Step 2: Adjust so that all decreases are worked on right-side rows

The next step, therefore, was to modify the chart so that all the manipulations (other than yarnovers, which are equally easy to work on both even- and odd-numbered rows) would be worked on just even-numbered, or right-side rows so that wrong-side rows could be worked "plain." The modified chart is shown at the bottom right of page 130.

At this point, I removed "extra" rows so that increases were worked about every four rows, as shown on the final doily chart on page 135.

Because the increases in the final doily chart are worked every four rows instead of every six rows, the resulting doily has eight wedges instead of the original ten. This is based on the geometric principles used to generate the table at right. According to this table, increases that are worked every second or fourth round will form an eight-wedge octagon or circle.

□ knit

· purl

○ yo

╱ k2tog

╲ ssk

■ remove beg of rnd m, knit first st of rnd, then replace m, shifting beg of rnd 1 st to the left

⚹ p3tog

⟍ sssk

⟰ s2kp

■ no stitch

☐ pattern repeat

Increases Required for Various Doily Configurations

Number of Wedges	Number of Increases per Round	Number of Increases per Wedge	Increase Every ____ Round(s)	Shape
3	12	4	3	triangle or hexagon
3	24	4	6	triangle or hexagon
4	4	1	1	square
4	8	2	2	square
5	20	4	5	circle
5	40	8	10	circle
6	12	2	3	hexagon or circle
6	24	4	6	hexagon or circle
7	28	4	7	circle
7	56	8	14	circle
8	8	1	2	octagon or circle
8	16	2	4	octagon or circle
9	36	4	9	circle
9	72	8	18	circle
10	20	2	5	circle
10	40	4	10	circle
12	12	1	3	circle
12	24	2	6	circle

Step 3: Expand the small flower motif

Based on experience, I knew that because I'd condensed the design into fewer rows, the center flower would appear too shallow. Because I wanted to maintain the proportions of the original pattern as much as possible, I made some other minor modifications to enhance the visual impact of that center motif.

The sequence of changes is shown in the three flower motif charts on page 133 (note that these charts are for illustration only and not meant to be used for knitting).

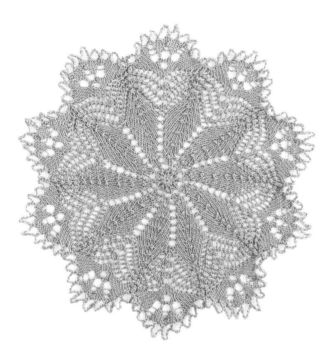

Original ten-wedge doily in which decreases are worked on even- and odd-numbered rounds.

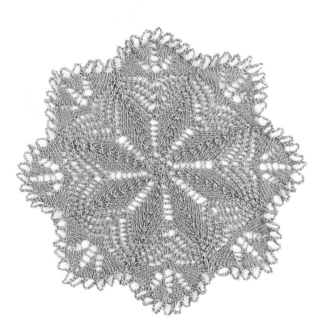

Modified eight-wedge doily with decreases worked on even-numbered rounds.

The first chart illustrates the original flower motif with stitch manipulations occurring on both right- and wrong-side rows. The second chart illustrates my modifications to put all of the stitch manipulations on right-side rows, which condensed the motif into fewer rows. I therefore added rows and detail to better resemble the original motif. I followed the second chart for the doily shown below left.

I enjoyed seeing both the differences and similarities between the two doily patterns. At first glance, it looks as though the eight-wedge doily is just a smaller version of the ten-wedge one, but, in fact, they're quite different!

Step 4: Plan the shawl

Although the doily wedges aren't symmetrical, I wanted my shawl to be balanced. To balance the chart, I placed a leaf and half a flower on each side of the repeat section. This required some creative decisions and a careful attention to stitch count. If you continue an increase line close to each edge, the shawl will curve in a crescent and wrap well around your shoulders. If you know what your increase rate is, you can consider it in your creative choices when balancing. A bit more than half a circle makes a perfect small shawl. For this project, I worked six of the eight wedges flat, which wraps around shoulders very well.

When you consider how deep you want your shawl to be, knit a swatch to determine your row gauge. Then, it's just a matter of some simple math to determine the length of the finished shawl.

number of charted rows ÷ row gauge = total length

For example, if your row gauge is 5 rows/inch (2.5 cm) and there are 40 rows in the chart, your shawl will be 8" (20.5 cm) deep.

40 rows ÷ 5 rows/inch = 8"

Conversely, you can multiply the desired length by the row gauge to determine the number of rows you'll need to chart.

For example, if you want your shawl to be 18" (45.5 cm) deep and your row gauge is 5 rows/inch (2.5 cm), you'll need to chart 90 rows.

18" × 5 rows/inch = 90 rows

Because I wanted a longer finished length, I extended the leaves over more rows, as illustrated in the three charts on page 134 (note that these charts are for illustration purposes only and are not meant to be used for knitting). To begin, I focused on the leaf motif in the original chart. Then I redrew the chart to isolate the leaf from the flower. Finally, I added more increase rows in the first half of the leaves and more decrease rows in the second half. This added more rows to the flower motif as well, which I elaborated slightly to keep the look as true to the original as possible. To mimic the texture of the purl-three-together decreases along the center of the leaves in the original doily, I added beads to each of the double vertical decreases in the shawl. I often use beads or nupps to replace the texture of purl stitches.

The results of my experiment are the two small projects that follow. You can use these guidelines for your own experiments!

Original Ten-Wedge Flower Motif

Increases and decreases are worked on both even- and odd-numbered rows in the original chart.

Modified Eight-Wedge Flower Motif

Moving all the increases and decreases to odd-numbered rows condensed the flower motif into too few rows, so I added extra rows and some twisted stitches for emphasis.

Balanced Eight-Wedge Flower Motif

To balance the pattern in the shawl, I placed a leaf and half a flower motif on each side of the expanded pattern repeat.

Legend

- ☐ knit
- • purl
- ○ yo
- ℓ k1tbl
- Ⓜ M1 without twist (see page 24)
- ╱ k2tog
- ╲ ssk
- ⋏ s2kp
- ● place bead
- ⋊ sssk
- ▨ remove beg of rnd m, knit first st of rnd, then replace m, shifting beg of rnd 1 st to the left
- ⋌ k3tog
- ▨ no stitch

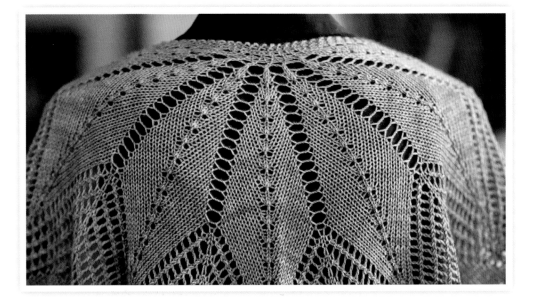

Original Eight-Wedge Leaf Motif

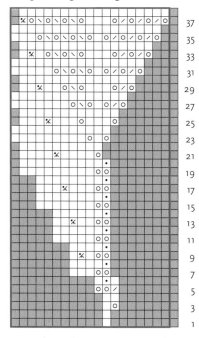

The leaf motif is connected to the flower motif in the original chart.

Isolated Eight-Wedge Leaf Motif

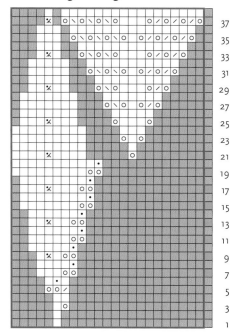

I redrew the chart using "no stitch" symbols to isolate the leaf motif.

Expanded Eight-Wedge Leaf Motif

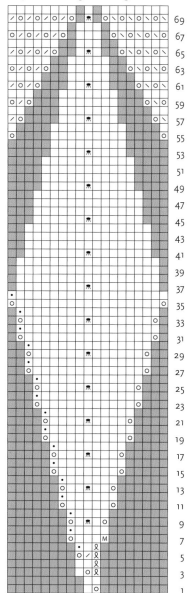

Finally, I added rows to the leaf motif to extend its overall length and, therefore, the length of the shawl.

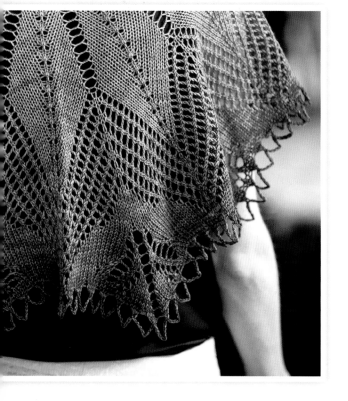

☐	knit
•	purl
☉	yo
⼋	k1tbl
╱	k2tog
╲	ssk
⋔	s2kp, place bead
⬤	place bead
▨	remove beg of rnd m, knit first st of rnd, then replace m, shifting beg of rnd 1 st to the left
▨	no stitch
☐	pattern repeat

The Purple Doily

This doily (shown at the bottom of page 132) measures about 10" (25.5 cm) in diameter at the widest point, blocked, and about 9½" (24 cm) in diameter at widest point, after relaxing.

MATERIALS

YARN

Laceweight (#0 Lace).

Shown here: Aunt Lydia Cotton Crochet Classic #10 (100% cotton; 350 yd [320 m]/ball (no weight is given): #0495 Wood Violet, 1 ball.

NEEDLES

U.S. size 1 (2.25 mm): set of five 7" (18 cm) double-pointed (dpn) and 16" (40 cm) circular (cir).

Adjust needle size if necessary to obtain the correct gauge.

NOTIONS

Size 4 (2 mm) steel crochet hook; at least one stitch marker (m); tapestry needle; T-pins.

GAUGE

18 sts and 28 rnds = 2" (5 cm) according to PurpleDoily Chart, worked in rnds and relaxed after blocking.

DOILY

With crochet hook, use Emily Ocker's Circular method (see page 18) to CO 8 sts. Divide sts evenly on 4 dpns so that there are 2 sts on each needle. Place marker and join for working in rnds, being careful not to twist sts.

Work Rnds 1–52 of Purple Doily Chart—264 sts.

With crochet hook, use the gathered crochet method (see page 17) to BO as foll: *gather 3, chain 6; repeat from *.

Use a slip stitch to join last chain st to the first group of gathered sts.

Cut yarn, leaving a 6" (15 cm) tail. Pull tail through rem loop to secure.

FINISHING

Weave in loose ends but do not trim tails.

Soak in cool water for at least 30 minutes. Roll in a towel to remove excess water. Place on flat padded surface and pin out each crochet loop to finished dimensions.

Allow to air-dry thoroughly before removing pins.

Trim tails on woven-in ends.

Purple Doily Chart

Chart row numbers (right side): bind off, 51, 49, 47, 45, 43, 41, 39, 37, 35, 33, 31, 29, 27, 25, 23, 21, 19, 17, 15, 13, 11, 9, 7, 5, 3, 1

Top repeat markers: 7 7 7 7 7 7 7 7 7 7 7 7

Bottom: 8 times

Legend:

- ☐ knit
- • purl
- ○ yo
- ╱ k2tog
- ╲ ssk
- ▓ remove beg of rnd m, knit first st of rnd, then replace m, shifting beg of rnd 1 st to the left
- ✕ p3tog
- ∧ s2kp
- ③ gather 3
- 0 crochet chain
- ▒ no stitch
- ☐ pattern repeat

The Purple Shawl

This shawl measures about 38" (96.5 cm) wide and 16" (40.5 cm) long at center back, blocked; about 36" (91.5 cm) wide and 14" (35.5 cm) long at center back, after relaxing.

MATERIALS

YARN

Fingering weight (#1 Extrafine).

Shown here:

Gradient Shawl: Lara's Creations Majestic Entrée ColourWave (50% silk, 50% merino; 430 yd [393 m]/100 g): "Your Highness," 1 skein.

Solid Shawl: Cascade Yarns Heritage Silk (85% merino, 15% silk; 437 yd [400 m]/100 g): #5625 Purple Hyacinth, 1 skein.

NEEDLES

U.S. size 5 (3.75 mm): 32" (80 cm) circular (cir).

Adjust needle size if necessary to obtain the correct gauge.

NOTIONS

12" (30.5 cm) smooth waste yarn for provisional cast-on; size 14 (0.75 mm) steel crochet hook for placing beads; 12 g of Japanese 8/0 Delica beads in color 906 Purple Lined Crystal (for one shawl); size 1 (2.75 mm) steel crochet hook for bind-off; tapestry needle; flexible blocking wires; T-pins.

GAUGE

11 sts and 14 rows = 2" (5 cm) according to Purple Shawl chart, relaxed after blocking.

Notes

A circular needle is used to accommodate the large number of stitches. Do not join; work back and forth in rows.

Beads are applied with smaller crochet hook (see page 16).

SHAWL

Using a provisional method (see page 19), CO 3 sts.

Knit 15 rows—7 garter ridges. Do not turn work after the last row.

Rotate work 90 degrees and pick up and purl (see page 25) 7 sts evenly spaced along selvedge (1 st in each garter ridge), carefully remove waste yarn from provisional CO and knit the 3 exposed sts—13 sts total.

Knitting the first 3 and last 3 sts of every row, adding beads with smaller crochet hook when specified (see page 16), work Rows 1–90 of Purple Shawl Chart—405 sts.

With larger crochet hook, use the gathered crochet method (see page 17) to BO as foll: gather 3, chain 8, [gather 4, chain 8] 2 times, gather 3, chain 8, *[gather 4, chain 8] 4 times, gather 3, chain 8; rep from * 19 more times, [gather 4, chain 8] 2 times, gather 3.

Cut yarn, leaving a 9" (23 cm) tail. Pull tail through rem loop to secure.

FINISHING

Weave in loose ends to but do not trim tails.

Soak in cool water for at least 30 minutes. Roll in a towel to remove excess water.

Weave flexible blocking wires into garter bumps along straight top edge. Place on flat padded surface and pin out each crochet loop to finished dimensions.

Allow to air-dry thoroughly before removing wires and pins.

Trim tails on woven-in ends.

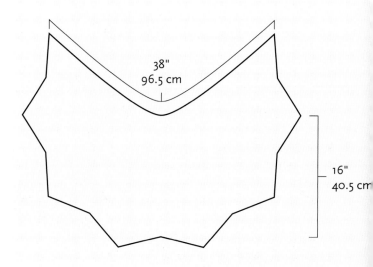

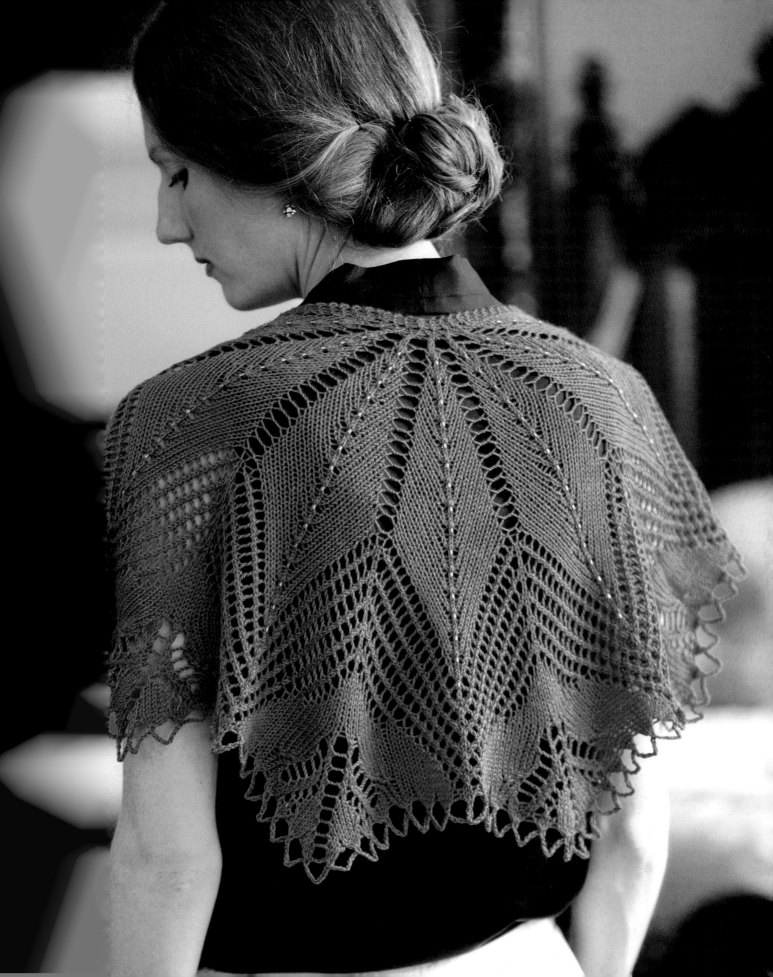

Purple Shawl Chart

Note: Stitches shaded blue are duplicated for ease of following the two halves of the chart; work the shaded stitches only once.

6 times

Knitting chart with "8" markers across the top and "bind off" at top right. Row numbers along the right edge: 89, 87, 85, 83, 81, 79, 77, 75, 73, 71, 69, 67, 65, 63, 61, 59, 57, 55, 53, 51, 49, 47, 45, 43, 41, 39, 37, 35, 33, 31, 29, 27, 25, 23, 21, 19, 17, 15, 13, 11, 9, 7, 5, 3, 1.

Legend:

☐	knit on RS, purl on WS
•	purl on RS, knit on WS
O	yo
ℛ	k1tbl on RS, p1tbl on WS
M	M1 without twist (see page 24)
⁄	k2tog
＼	ssk
⅏	s2kp, place bead
⋀	s2kp
●	place bead
⋊	sssk
⋉	k3tog
⬆	gather 3
⬆	gather 4
0	crochet chain
▨	no stitch
☐	pattern repeat

Sources for Supplies

SOURCES FOR BEADS AND TOOLS

Artbeads
11901 137th Ave. Ct. Kp N
Gig Harbor, WA 98329
artbeads.com

Source of Japanese seed beads.

Fusion Beads
3830 Stone Way N.
Seattle, WA 98103
fusionbeads.com

Source for Japanese seed beads.

Inspinknity
Rachel and George Calado
24 Lackey Dam Rd.
Sutton, MA 01590
inspinknity.com

Source for very long, flexible blocking wires for the projects in this book. The Premium wires are ideal great for long, straight edges and curves, and the Ultra Fine wires are great for scallops.

Lacis Museum of Lace & Textiles and Lacis Retail Store
2982 Adeline St.
Berkeley, CA 94703
lacismuseum.org, lacis.com

Resource for all things related to lace. Lacis carries knitting needles, crochet hooks, blocking pins, cotton crochet threads, and books.

SOURCES FOR YARN

Cascade Yarns
PO Box 58168
1224 Andover Park E.
Tukwila, WA 98188
cascadeyarns.com

Classic Elite Yarns
16 Esquire Rd., Unit 2
North Billerica, MA 01862
classiceliteyarns.com

Coats and Clark/Aunt Lydia's Yarn
PO Box 12229
Greenville, SC 29612
coatsandclark.com

ColourMart
Unit 2A, Archers Way, Battlefield Ind Est,
Shrewsbury, SY1 3GA
United Kingdom
colourmart.com

Crystal Palace Yarns
160 23rd St.
Richmond, CA 94804
straw.com

DMC Corporation
10 Basin Dr., Ste. 130
Kearny, NJ 07032
dmc-usa.com

Fairmount Fibers/Manos Del Uruguay
PO Box 2082
Philadelphia, PA 19103
fairmountfibers.com

Jade Sapphire
jadesapphire.com

Knitting Fever Inc./Malabrigo
PO Box 336
315 Bayview Ave.
Amityville, NY 11701
knittingfever.com

Land O Lace
514 Arrowhead Dr.
Lino Lakes, MN 55014
landolace.com

Lara's Creations
909 Pinon Ct.
Longmont, CO 80504
etsy.com/shop/larascreations

Madelinetosh
7515 Benbrook Pkwy.
Benbrook, TX 76126
padelinetosh.com

Pagewood Farm
790 West Basin St., Ste. 1
San Pedro, CA 90731
pagewoodfarm.com

SweetGeorgia Yarns
110-408 East Kent Ave. South
Vancouver, BC
Canada V5X 2X7
sweetgeorgiayarns.com

Bibliography

BOOKS

de Dillmont, Therese, ed. D.M.C. *Library Knitting 5th Series.*
Mulhouse, France, year unknown. Antiquepatternlibrary.org/html/
warm/main.htm.

Kinzel, Marianne. *First Book of Modern Lace Knitting.* New York:
Dover, 1972.

–––. *Second Book of Modern Lace Knitting.* New York:
Dover, 1972.
Niebling, Herbert. Schöne Spitzen. Leipzig, Germany:
BuchVerlag Für die Frau, reprint 2011.

Thomas, Mary. *Mary Thomas's Knitting Book.* New York:
Dover, 1972.

Zimmermann, Elizabeth. *Knitter's Almanac.* New York:
Dover, 1981.

–––. *Knitting Without Tears.* New York: Charles Scribner's
Sons, 1971.

Old German Magazines and Leaflets with No Other Notations
Elsa Kunststrickheft Sonderheft 3047. Wiesbaden, Germany:
Verlag Johannes Schwabe, 1959.

Kunststricken 1698. Leipzig, Germany. Verlag für die Frau, year
unknown.

Mez Handarbeitsvorlage 7008. City unknown but possibly
Frankfurt, Germany: Mez thread company, year unknown.

Index

DISCOVER *exquisite & delicate* DESIGNS
WITH THESE GORGEOUS RESOURCES FROM INTERWEAVE

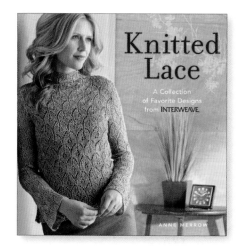

WRAPPED IN LACE
Knitted Heirloom Designs
from Around the World

Margaret Stove

ISBN 978-1-59668-227-6
$26.95

KNITTED LACE
A Collection of Favorite
Designs from Interweave

Anne Merrow

ISBN 978-1-59668-482-9
$24.95

FREE-SPIRIT SHAWLS
20 Eclectic Knits
for Every Day

Lisa Shroyer

ISBN 978-1-59668-904-6
$24.95

INTERWEAVE KNITS

From cover to cover, *Interweave Knits* magazine presents great projects for the beginner to the advanced knitter. Every issue is packed full of captivating smart designs, step-by-step instructions, easy-to-understand illustrations, plus well-written, lively articles sure to inspire.
Interweaveknits.com

knitting daily

Join Knittingdaily.com, an online community that shares your passion for knitting. You'll get a free eNewsletter, free patterns, projects store, a daily blog, event updates, galleries, tips and techniques, and more. Sign up for *Knitting Daily* at **Knittingdaily.com**.